Monet to Dalí

Monet to Dalí

Impressionist and Modern Masterworks from the Cleveland Museum of Art

An Exhibition Organized by

William H. Robinson

THE CLEVELAND MUSEUM OF ART

IN ASSOCIATION WITH HUDSON HILLS PRESS 2007

Published by the Cleveland Museum of Art and distributed by Hudson Hills Press LLC, Manchester and New York

ISBN: 978-0-940717-89-3 (paper)
ISBN: 978-0-940717-90-9 (cloth)

Library of Congress Control Number: 2007921666

Produced by the Publications Department of the Cleveland Museum of Art to accompany a traveling exhibition on view at venues in North America during 2007 and 2008.
Text by Laurence Channing and Barbara J. Bradley with contributions from Margaret Burgess and William H. Robinson.

Editing: Barbara J. Bradley and Kathleen Mills
Design: Laurence Channing
Production: Charles Szabla
Photography: Howard Agriesti and Gary Kirchenbauer
Digital scanning: David Brichford

The international tour of *Monet to Dalí: Impressionist and Modern Masterworks from the Cleveland Museum of Art* was supported in part through a grant from The Timken Company, a CMA Global Partner.

The Ohio Arts Council helped fund this exhibition with state tax dollars to encourage economic growth, educational excellence, and cultural enrichment for all Ohioans.

CONTENTS

Almost half the works in this exhibition—the core of the museum's collection of late 19th- and early 20th-century European art—came to the museum through the generosity of one man. The Cleveland Museum of Art rests on a foundation of private giving. Funds for acquisition and operations, many stellar objects, the buildings, the very land beneath them, were gifts from inspired individuals, just as in many other American museums. Yet, in Cleveland, this beneficence took a strikingly individual form that informed the museum's growth in important ways, and continues to shape its development.

Over the years, lovers of art and civic duty who aided the museum have been many, and no single name is engraved over the door. But if at one time the museum had been called the Hanna Museum of Art no one would have been surprised. Through gifts of art and money Leonard C. Hanna Jr. turned a striving, ambitious organization into a collecting powerhouse, yet, paradoxically, his contributions created an institution remarkable for the lack of a personal stamp of taste or attitude, whose hallmark is active, independent professional judgment as well as the cultivation of donations.

If Leonard Hanna's temperament had been different Cleveland would have had another Phillips Collection, perhaps, or a Getty Museum. Indeed, though Hanna's personal collection was on the highest level his tastes were simple: he liked many things as long as they were very, very good. He needed no help to discern quality, and he could afford almost anything on the market. So why didn't he control the museum's growth from its inception to 1957, when his bequests made the museum's first expansion possible?

A passionate sports fan and theater buff, with friendships ranging from Cole Porter and George Gershwin to Gene Tunney, Hanna cannot have possessed a colorless personality. Perhaps his disinclination to impose it lay in his regard for art as a kind of civic resource rather than private property—something you owned in trust for others. Furthermore, the involvement he sought with the museum was as a member of a team. He certainly felt free to recommend objects for purchase, but left it to the curators and acquisition committee to accept them. If accepted, they were purchased with funds from a non-profit corporation he headed that was equally willing to fund purchases selected by curators. In this way Hanna not only built the collection, but also cultivated the professional judgment of his colleagues, testing their ability to respond to opportunity quickly and decisively.

As this exhibition demonstrates, Hanna's contribution was more nuanced than the simple provision of lots of money. Although he collected widely from many cultures, his

interest centered on European art from the rough century embraced by this exhibition, from the Second Empire in France to the Second World War: classical modern art and its origins. Since 1957, the professional culture he fostered has continued to strengthen the collection in this area, as in many others, and the growth of the museum he did so much to stimulate has sparked a tremendous renovation program, much more extensive than the one he supported in the 1950s, that has temporarily deprived the objects in this exhibition of their galleries. Hence this opportunity to share these treasures of the collection with other cities.

An enterprise of this scope requires much organizational acumen and many skillful hands. The exhibition was conceived and organized by William H. Robinson, Curator of Modern European Art, responding to the entrepreneurial initiative of Charles L. Venable, Deputy Director for Collections and Programs, to convert the inaccessibility of the collection during construction into an opportunity to acquaint an international audience with its riches. Bill was assisted with research by Margaret Burgess, Cleveland Fellow in Modern Art, and with administration by Curatorial Assistant June de Phillips. The myriad arrangements of the tour were coordinated by Heidi Strean, Director of Exhibitions. Chief Conservator Bruce Christman and his colleague Marcia Steele, Conservator of Paintings, performed the analysis needed to determine which works could travel, and ensured their safety through exacting specifications. Registrar Mary Suzor was assisted with shipping and insurance by Gretchen Shie Miller, Associate Registrar for Loans. Packing Specialist Larry Sisson supervised the packing and crating required for a marathon tour. Labels for the exhibition were compiled by Editor Jane Takac Panza. This elegant and affordable catalogue was produced by Director of Publications Laurence Channing and Senior Editor Barbara Bradley.

All of them join me in the hope that visitors to this exhibition in cities around the country will enjoy this group of stellar objects, and recognize that they present only a fraction of what the Cleveland Museum of Art has to offer. We look forward to welcoming you to our new museum soon.

Timothy Rub, Director

Among broad human endeavors the arts are surely the most mercurial, their development less linear than, say, medicine. None of us would prefer to visit a first-century Roman dentist, yet the sculptor in the *officina* next door might produce a portrait bust superior to any that could be made today. Portraiture has not necessarily declined, but its ambitions and means of production have changed, just as the successive waves of revolution that swept through Western art from the mid 19th to the mid 20th centuries represent neither improvement nor decline, but reinvention, as each generation of artists sought fresh areas of experience to explore.

This burst of creative energy attracted the attention of American collectors and museums, and the Cleveland Museum of Art is the lucky beneficiary of the energy of several alert collectors, especially Leonard C. Hanna Jr., who gave many important Impressionist and Post-Impressionist works and the funds to purchase many more. When paintings such as Claude Monet's *The Red Kerchief: Portrait of Mme Monet,* painted around 1870, are compared with earlier works in the collection, such as Gustave Courbet's portrait of Laure Borreau from 1863, and later ones such as Pablo Picasso's *La Vie* of 1903—also acquired through Hanna's perspicacity—an extraordinary range of creativity is revealed on the part of artists working in the same country, even the same city, over a few decades.

In the diversity of styles in this selection of works of European art from this crucial century—roughly from the middle of the Second Empire to the Second World War—we can see the great enterprise of art through many different lenses, filtered by different disciplines. Most salient is the geographic centrality of Paris and the defining effect of French culture, so influential in northern Europe and the British Isles; give the telescope another twist, and the formal innovations of Post-Impressionism and Cubism suggest an avid appetite for innovation you won't find even in cultures of great refinement, such as Edo-period Japan, for example; or we might notice the increasing interest in subjective experience and the visualization of inner psychological states that animates the work of the Nabis and became the program of the Surrealists.

Yet our telescope reveals overlapping characteristics shared by many paintings and sculptures, so that we won't miss the radical individuality of Vincent van Gogh's color in the service of his drive toward expression, the psychological penetration of Édouard Manet's portrait of Berthe Morisot—even though it seems to have been improvised like a bebop solo—or the sensual eroticism in the severely abstract sculpture of Constantin Brancusi. (Dialectic is a specialty of art, which can blithely reconcile opposites the way religion

can, and as science, for example, cannot.) The works in this exhibition present the same richness of variety and contradiction as human experience itself, and defy categories.

The lenses of geography, formal invention, and psychology are very sharp, but there is another even more penetrating: epistemology. Does our knowledge of the world differ from our perception of it? Is anything true besides empirical experience, and can it be made visible? And, for the artist, is there an aspect of reality ignored, perhaps unsuspected, by those tedious old teachers who drove us crazy in art school, something so pervasive, so trenchantly human, that our treatment of it will obliterate their names forever, except as footnotes in our development? Let us talk of Charles Gleyre.

Usually mentioned today as the leader of an atelier where the fractious Monet, Auguste Renoir, Alfred Sisley, and Frédéric Bazille briefly studied, Marc-Charles-Gabriel Gleyre was a gifted artist and intellectual. Born in Switzerland in 1806 and consequently ineligible for certain Second Empire benefices, he triumphed over his disadvantages by perseverance and talent, and ultimately enjoyed significant official patronage. Yet Gleyre was no conforming careerist; his original allegories and scenes from history and legend were based on close study of the archaeology of the Near East, and his individual sensibility gave them a melancholy authority with the conviction of personal experience. In his best work the ancient world casts a long, sad shadow into the future, as the origin of everything serious and memorable about human existence.

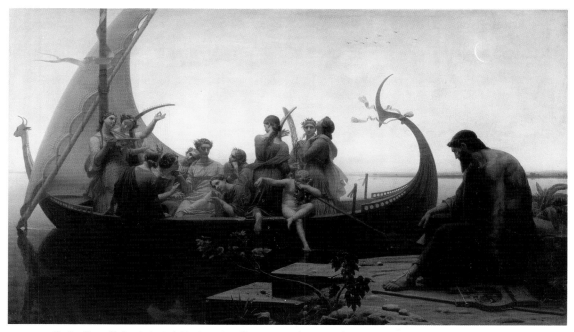

Charles Gleyre (Swiss, 1806–1874). *Evening, or Lost Illusions,* 1843, oil on canvas, 156 x 238 cm. Musée du Louvre, Paris, inv. 10039.
Photo: D. Arnaudet/G. Blot. © Réunion des Musées Nationaux/Art Resource, New York

Gleyre's atelier was famous; it had belonged to Jacques-Louis David. Gleyre ran it progressively, allowing the students to participate in its governance. He took no fees, charging only for rent and models, and the atelier was popular. But the figural tradition of the Renaissance as taught in the French academy, the tonal modeling in which color was mere decor, the corny choreography that Auguste Rodin called "the theatrical art of the Academy," and especially the tyranny of imagery from the classical world, still considered a guarantee of seriousness—in short, the past—was its reason for being. Gleyre cherished a certain decorum and considered rhetorical idealization aesthetically necessary. The avuncular academician advised Monet, who was to change the direction of Western landscape painting: "Not bad, not bad at all, this study. But it is in too much the character of the model. He has gigantic feet so you render him that way. It is very ugly, all that. Remember, young man, that in rendering a figure one must always think of the antique. Nature, my friend, is very beautiful as an element for study, but it does not offer interest beyond this. Style, you must understand; that's the thing."

Style was indeed the thing during the Second Empire, with all its pretension and privilege for hire. The disappointment of the republican ideals of 1848 still smarted, and the neoclassical aesthetic, recycled from the empire of Napoleon I, was the official style of a distrusted regime. Ironically, Gleyre shared his students' republican sentiments; he refused official commissions and the Légion d'honneur, and they loved him for that. But history painting was his world because the draped figures, the Pompeian ornaments (excavation had recommenced in 1848), and the primal literature of Homer and the Bible represented an eternal reality, deeper than the visible; he was painting what he believed in, not what he saw—except that his fictions were constructed with the aid of models and props. Of course many of his students, such as Léon Gérôme, were content to continue the tradition, but those about to invent Impressionism rejected it.

The artists who in 1848 had pulled down the obelisk in the Place de la Concorde—a symbol of imperial power—struck a blow for republicanism (and got their mentor, Courbet, in deep trouble with the regime), but they had little to put in place of the classical tradition. Fifteen years later, the realism of Courbet and Camille Corot had been digested; Barbizon landscape, painted in the open air, was influential; and the basis existed on which to erect a new aesthetic. Monet, Renoir, Sisley, and to some extent Bazille rejected neoclassical imagery as imperial propaganda and drawing plaster casts of ancient

sculpture as fear of reality; they hated working in a dusty atelier instead of under the open sky and painting in grays and browns that reminded them of mud, or worse.

Beneath the response to artistic education and practice shared by these young men lay the broad skepticism of any received opinion, any notion you had to take on faith. Besides their middle-class disdain of social privilege and imperial politics they shared a profound belief in the empirical, of the evidence of the senses, and distrusted belief systems ordained by custom or authority. When Monet began painting in the company of Eugène Boudin and Johan Barthold Jongkind he discovered that his subject was not only what he was looking at, but the experience of seeing it, what he called the *effet*. Of course we correctly translate this word "effect," but it's also "the unique relationship of these scenic elements at this moment, in this singular painted representation, that reveal something about my experience of the world I can share with you only in this way." Not just the river, the bridge, the house, but the optical encounter, the fact of light bouncing off a motif into an artist's eye.

This personal response to the natural world was realized in distinct brushstrokes that Monet took care to leave separate, not blended together, in direct contradiction of Ingres's famous injunction that visible brushstrokes directed the viewer's attention not to the subject, but to the artist's hand. As a student, you were required to produce *esquisses* (sketches) in which the brushstrokes were left distinct to reveal the process, so that the teacher could give you a hard time. But when you had produced a satisfactory esquisse you went on to finish the work by blending the strokes together. The ideal of academic painting was a smooth, physically anonymous surface, conceptually transparent, that revealed the subject without interference, with the bland legerdemain of a movie screen. Thus the representation was intrinsically fictitious, with a movie's relation to reality. But the kind of art invented by the Impressionists and their colleagues produced not fiction, but additional reality: the artist's response to life, inextricably bound to visual experience, rather like poetry's relation to life in its resistance to translation into another medium.

Thus the Impressionist generation changed the relationship of painting to reality. An Impressionist painting was not just a picture of something; it was another thing, a physical artifact at the nexus of a view of the world, the sensibility of an artist, and the response of a viewer. The echoes of this artistic Big Bang are still audible and may always be; Jasper Johns is still tinkering with the relationship of subject and representation, and digital

imaging, with its potential for a unison relationship with experience, may have created a new epistemology of object and image. But for the century or so of our exhibition the revolution was permanent.

This exhibition also allows us to bring into focus another accelerated artistic development that was especially dramatic in the century between 1850 and 1950: the tremendously accelerated pace of the invention of new pictorial structures, especially with regard to the depiction of three-dimensional space and the use of color. Like a software operating system designed to be augmented by its users, art may be thought of as a sort of machine that is changed by those who use it. Of course this has been happening since the time of the Altamira cave painters, but in the early years of the period in our exhibition artists became more and more eager to add to the code, and their innovations changed the direction of Western art.

Already embedded in the software was the strong classical tradition that runs through all European art, enshrining the values of order, seriousness, and restraint within imagery drawn from the classical world. Throughout the period of the exhibition the great 17th-century painter Nicolas Poussin was universally acknowledged as its leading exponent. His first biographer, the 17th-century scholar Giovanni Pietro Bellori, tells us that Poussin defined beauty as having three aspects: order, measure, and form. In a letter to a friend, Poussin wrote, "My nature compels me to seek and love well-ordered things and avoid confusion." Academic artists revered Poussin for his philosophical allegories, but he was equally cherished by the avant-garde for the rigorous logic of his compositions and the way his color relationships articulated the relationships among the figures and clarified the meanings of his pictures. In other words, they recognized that Poussin had invented a pictorial world in which everything made a special kind of sense defined by the artist, or as we might say today, his pictures are successful abstractions.

By this standard, some contemporaries of the Impressionists found Impressionism lacking in formal rigor. Georges Seurat sought order, measure, and form in color theory and the drawing of Jean Auguste-Dominique Ingres. A pupil of Ingres's pupil Henri Lehmann, who revered Poussin, Seurat copied Poussin's self-portrait. He created his own style out of Impressionism, basing it on tiny dots of strong color that mix when you look at them without allowing you to lose sight of the painting as a constructed artifact that reminds you to seek and love well-ordered things. Seurat (and others, especially Camille

Pissarro, who found this method very persuasive) considered it scientific, meaning that it responded to how they believed light and vision actually interact. The relationship of Pointillism to what is seen is one of analogy, not illusion, and that made it modern and interesting. As art, its view of realism was sophisticated: a reminiscence of the physical world constructed by the same means the artists believed that nature used—the substance of reality, not mere appearance.

Paul Cézanne is supposed to have said that he wanted to do Poussin over after nature—to bring Poussin's formal clarity to a personal response. Perhaps working outdoors directly from the motif rescued Cézanne from his overheated figures of the 1860s outlined in tarry black. In these works his powerful feelings are sensed mainly as frustration, but once he turned to a celebration of the natural world in an Impressionist idiom, the experience of working in a mode beyond illustration may have enabled him to transform the Impressionist vocabulary of broken color into a powerful abstract style.

Before Cézanne and Seurat, formal excellence might be sought in systems of order imported from theology and geometry, such as the iconography of cathedral sculpture or the proportions of the Golden Mean, that were invoked to give intellectual authority to form in art and architecture. Cézanne, too, found geometry a repository of ideal form, but he sought it within the work rather than applying it from without; his injunction to Émile Bernard to "treat nature by means of the cylinder, the sphere, the cone" was aimed at bringing out the primal forms inherent in the picture's motif, using them as a matrix for the colored shapes he invented to represent his works' ostensible subjects.

This was the beginning of the notion that form can be represented by means other than illusion and that art can visualize aspects of experience that would otherwise remain hidden. Poussin's theater of allegory, in which carefully wrought figures act out scripts designed to illustrate philosophical propositions, also had a parallel relation to daily reality, and a sublime degree of consistency—the beauty of the ideal, of a world where everything makes moral and aesthetic sense. When Cézanne's young contemporaries recognized that ideal form could be abstracted from nature, a tremendously powerful conceptual tool was created that encouraged artists to invent form for themselves. When many years later Maurice Denis, perhaps more influential as a theorist than an artist, referred to Cézanne as the Poussin of Impressionism, he intended to give the earnest, cranky old artist the status of an immortal.

Only a few years after the death of its first user this tool fell into the hands of one of human history's most protean creators, Pablo Picasso. Together with Georges Braque, Picasso invented a language that tremendously expanded the capacity of artists to engage the visual actively; to change the world instead of passively accepting its appearance. And yet Cubism, as this style came to be called, was no flight from reality. It was a research program aimed at a redefinition of reality that would include the unseen by acknowledging that all representations were notional—ideas, not facts. Truth was to be approached by a form of notation invented by the painter, who would use simplified solids and planes to give timeless monumentality to the objects they represent, which were liberated to interact in unique ways created for them by the artist.

At its core Cubism was about form; though color quickly asserted itself in these beautiful works, they are sober compared to the paintings by the artists around Henri Matisse a few years before, in which color was deployed so exuberantly that Matisse and André Derain (and Maurice de Vlaminck and others not represented in the exhibition) earned the nickname *fauves*, "wild beasts." Cézanne's use of color was highly refined and, while it emphasized primaries (a chromatic analogy to the basic geometry he sought in nature), restrained; the fauves used color as though it had just been created, rather like someone who had admired a violin for its shape for years before suddenly realizing that it made sounds. Color became a primary structural component of much 20th-century art; see *Composition with Red, Yellow, and Blue* by Piet Mondrian in this exhibition. Forty years later, confined to bed in a hotel in Cimiez, Matisse was still playing that violin, drawing huge shapes on the wall for his assistants to cut out of sheets of paper painted in brilliant colors.

Let us use one last lens, one that magnifies how the artists in our exhibition developed their means of emotional expression. To focus it, let us pretend for the moment that subjective experience has always been the proper subject for art and that literal depiction of the world, which became the dominant agenda in European art during the 18th and 19th centuries, was an aberration, a detour from a broad trajectory that connects medieval art, which was largely devoted to spiritual experience and the promulgation of dogma, to the secular exploration of psychology in Surrealism. According to this supposition, though the Surrealists used realistic images of the concrete everyday, the goal was the invisible. The medieval artist had no need to achieve convincing resemblance to

the everyday world—his subject was the spiritual realm, and the realism of the drolleries in the margins of illuminated manuscripts was intended merely as a diversion. Furthermore, the rediscovery of classical culture in the Renaissance added only to the vocabulary of the pictorial arts while further consecrating the ideal as subject matter. Even in portraiture, where realism is essential, it may be seen as a mere functional necessity, which consigns it to a less exalted level of expression.

While the dogmatic eccentricity of this view proves that this lens distorts a bit, the persistence of subjective experience in art is undeniable, and in the 19th century became a trend identifiable in the work of artists that is otherwise dissimilar. Those writers and artists who lost confidence in material reality as a subject for art believed that human existence is ultimately mysterious. They sought intuitive, imaginative knowledge in altered states induced by dreams, music, and alcohol: Edgar Allen Poe's formulation, "All that we see or seem/Is but a dream within a dream" ("A Dream Within a Dream," 1827) and Richard Wagner's music dramas, almost a cosmogony of myth and legend, deeply influenced European art throughout the 19th century.

In painting, the grand fictions of Théodore Géricault and Eugène Delacroix revealed an energy and urgency denied to traditional history painting, starved of imagination by laborious illustration. Then Courbet expanded realism to confront the facts of modern life, and showed artists the way toward areas of experience hitherto claimed mainly by literature. The best of the artists concerned with subjective reality created complete worlds, instantly recognizable as their own. While the Impressionists made art outdoors from air and light, Gustave Moreau labored in the studio shadows on images that could never have arisen in Monet's Argenteuil or Giverny, and Odilon Redon and Georges Rouault continued to enlarge this domain and its population of strange, revelatory creatures. Van Gogh appropriated the methods of Impressionism to depict fierce landscapes of his imagination, and Paul Gauguin traveled as far into his country of invention and dream as he ranged across the globe. Henri Rousseau found his enchanted country without leaving Paris, bewitching the avant-garde, especially Picasso, in whose work emotional expression is as powerfully original as formal invention. Matisse created a sort of paradise of form and color, a land of Light, Calm, and Pleasure that nevertheless acknowledged and transcended time and tragedy, and the Surrealists turned the tables on realism by giving literal, illustrative form to the world of dreams. And at the mid 20th century, in the

aftermath of two world wars, Rouault was still applying Moreau's approach to emotional truth, with a concentration on religious imagery in striking symmetry with the origins of expressionism in medieval art.

Roped together, as Braque said of Picasso and himself, like mountain climbers, the artists in this exhibition built on one another's ideas and discoveries, creating a legacy of beauty and humanity that may almost redeem the century of calamity and chaos they lived through. Around the time of the latest work in this show, Picasso and Matisse surveyed from the heights of age the tremendous distance they had traveled. Flipping through a book of newly minted Abstract Expressionism, Matisse asked the other Olympian, "And in a generation or two who among the painters will still carry a part of us in his heart, as we do Manet and Cézanne?" He need not have worried.

Laurence Channing, Director of Publications

The Accuracy of Things

The Impressionist Epoch

O ctave Mirbeau, the Impressionists' champion among the writers, wrote of *Wheat Field* by Monet, "He draws his effects solely from the accuracy of things," meaning that Monet's truthful response to a simple view across a field was sufficient for a masterpiece. Monet and his pals wanted to work from contemporary reality, from incontrovertible physical fact. Following the example of Corot, Jongkind, and Boudin, they decided to work directly from nature in the out-of-doors, and discovered an inexhaustible subject: the experience of nature.

Today it may be hard to realize how radical this seemed. Conventional taste demanded skillful illustrations of objects and spaces—touching scenes, young girls, bold musketeers, puppies—painted in a fashion that made the painted artifact a clear window from which all traces of the hand had been smoothed away. The Impressionists never let you forget that you were looking at a painting, an object of canvas and paint.

Their work began one of the richest chapters in the history of art—a chapter that in a sense never ended, because Impressionism, originally reviled, is still universally popular. It also had an especially long life as an active school, because its concentration on the visible led generations of artists to an exploration of nature as a source for color that could function independently of form. Gradually escaping its traditional role as an identifier of objects, Impressionist color founded a realm where painting is reality, a unique world of sensory delight.

First in the work of Seurat and Cézanne, and then in the work of Vuillard and Bonnard, the Impressionist unity of brushstroke and color became a primary structural element. Matisse and his circle transformed the Impressionist idiom into the glorious festival of color known as Fauvism. Bonnard continued to expand an essentially Impressionist vocabulary throughout his life—which ended only a few years before the period covered by this exhibition—in works that remain unrivaled for their intimate expression and sensuous color.

Laure Borreau 1863

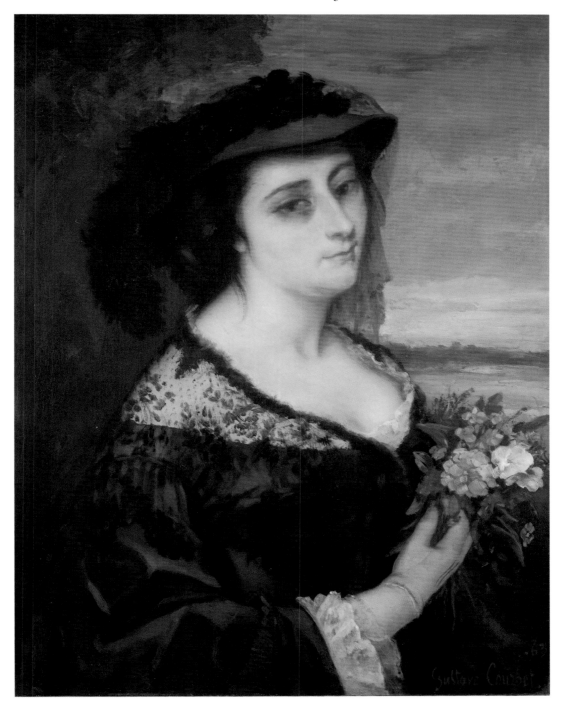

"I am in love with a splendid lady, the driving force behind my triumph," wrote Courbet, whose visit to Saintonge province was extended by the lady's charms, and the production of three portraits of her. When exhibited, this work was ridiculed in the press by critics who could not tolerate its lack of conventional artificiality ("Everything he touches becomes unpleasant") and the artist's disdain for the superficial glamour of the society portrait ("So this is what M. Courbet makes of a pretty woman"). The expression of sentiment is not unconventional, with a bouquet of carnations and the dying embers of the sunset. But the sensual presence of a cherished woman, thrust toward us by the contrast of her skin with her black lace and silk, transcends what might have been just another essay in 19th-century romanticism, just as Courbet's powers of evocation and suggestion transcend his militant realism.

Romaine Lacaux 1864

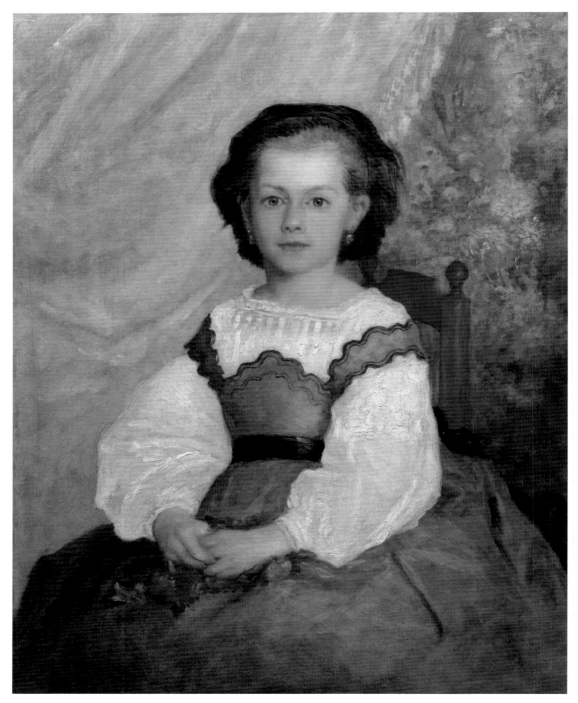

Renoir painted this charming portrait just after he turned 23. Disenchanted with the instruction of the academician Charles Gleyre, he and three fellow students (Monet, Bazille, and Sisley) began painting directly from nature in the forest of Fontainbleau. While vacationing there, the Lacaux family commissioned this portrait of their daughter. Eager to experiment, Renoir abandoned his dark tonal palette for brilliant color and even destroyed many of his earlier paintings, leaving this as his earliest signed and dated portrait. Yet, he was still a student, experimenting with various styles: the hair imitates Rubens; the crisply defined face and lacy bodice derive from Ingres; the white impasto suggests Courbet; the soft floral background pays homage to Corot. Almost miraculously, however, out of these disparate elements Renoir created a painting that is unmistakably his own, possessing the special warmth and affection characteristic of his greatest works.

Marie-Yolande de Fitz-James 1867

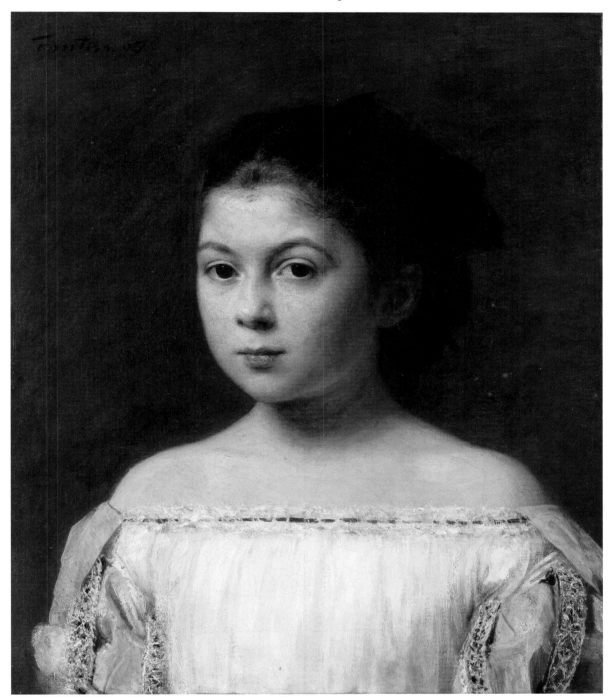

Though close to the Impressionists and a good friend of Manet, Fantin-Latour did not work outdoors; the studio was his natural home. After his portrait of Manet attracted attention at the Salon of 1867, his portraits became fashionable. He painted the family of the Duke of Fitz-James while a somewhat intimidated guest in his house ("You can imagine how extraordinary it is to be launched into such company!"). He presented the duke's youngest daughter with the 16th-century formality of the Clouets or Corneille de Lyon, with a sense of style nourished by hours in the Louvre. There he could usually be found until the Franco-Prussian War made it inaccessible, copying the work of masters he most admired, especially Titian, Velázquez, and Watteau. It was there Fantin met Whistler in "a crazy hat," who introduced him to artists and collectors in England, where his careful realism made him popular.

Stefanina Primicile Carafa, Marchioness of Cicerale and Duchess of Montejasi c. 1875

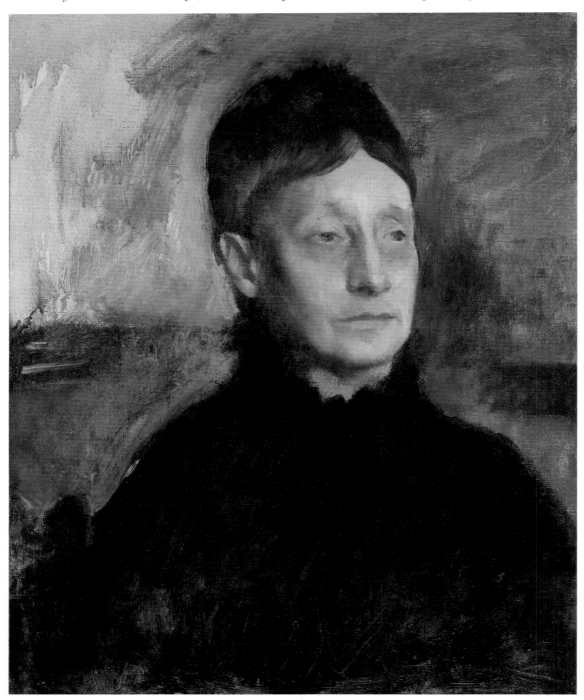

The artistic milieu of the Impressionists was an aristocracy of talent, but socially democratic. Degas's background of privilege was not held against him, though Pissarro did once complain, when exhibiting with him, that Degas could afford to insist on conditions that made sales difficult. The lofty rank of Degas's aunt Stefanina Carafa, an Italian duchess, is evident in her carriage and assurance, without any props of jewelry or clothing. Her mourning dress was probably for her brother, Degas's paternal uncle.

This is one of several studies for a single magnificent painting of the entire family. These studies, relatively informal, reveal his methods, such as the masterful concision of his modeling. One of history's greatest draftsmen, Degas grasped and depicted three-dimensional form with absolute authority. The severe palette and economy of gesture, without a superfluous brushstroke, exemplify the dignity of the sitter.

Berthe Morisot c. 1869

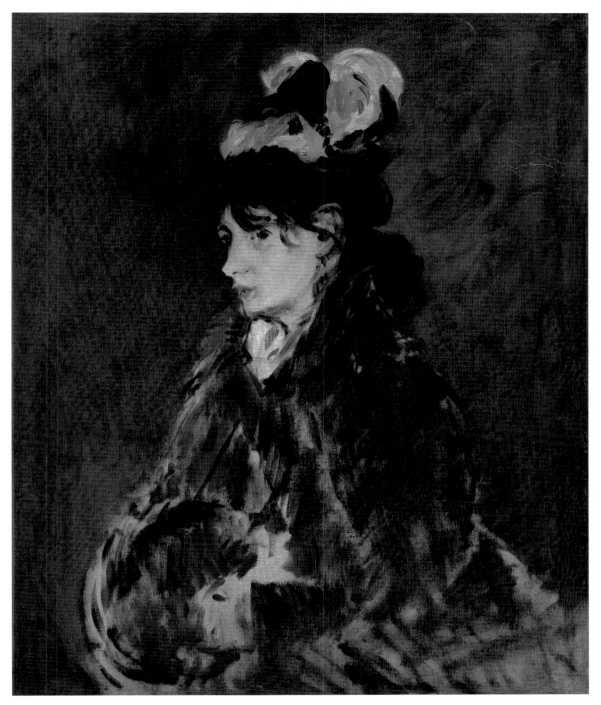

Morisot posed for Manet more often than any other woman. After he died she wrote to her sister Edma of how his "charming wit kept me alert during those long hours." Her colleagues respected the beautiful Morisot as an artist, and she fought in all their battles with critics and the public. Here Manet, the most experimental of their circle, has done her the honor of painting her in a fashion daring even for him; he made this image of her a declaration of his idea of realism, which included emphasis on the physical reality of paint and canvas as well as the facts of modern life.

Here she seems to have dashed in, none too warm in her coat and muff. Manet seems to have painted her at the headlong pace of their lives, in a treatment that combines admiration and affection and has preserved forever her caffeinated charm and intense, curious eyes.

Panoramic View of the Alps, La Dent du Midi 1877

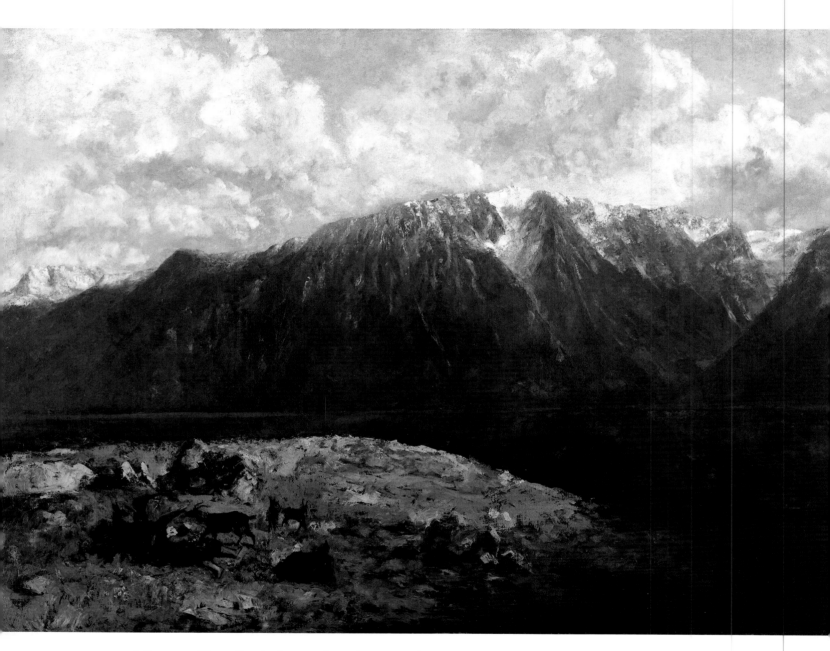

A fierce republican, Courbet's sympathetic depictions of working people had already earned him a reputation as a socialist when his complicity in the revolution of 1871 incurred the implacable enmity of the Bonapartist deputies of the Third Republic, who imprisoned him, confiscated his paintings and property, and levied a ruinous fine. Broke, sick, and on the run, he nonetheless summoned the strength for this monumental view of the French Alps from his Swiss refuge. He would never return to France.

As in all Courbet's work, reality is confronted directly. In this painting the sky and mountain peaks are charged with his familiar energy, but the lower half of the painting is treated more loosely and the lower right corner was still unfinished in the spring of 1877, when his sentence was reconfirmed. He stopped painting, and died a few months later.

The Beach at Deauville 1864

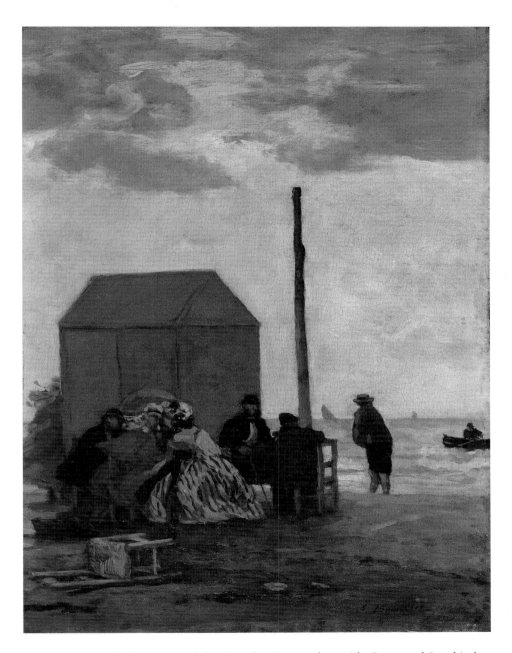

As early as 1883 a critic had announced that Boudin "is, together with Corot and Jongkind, one of the immediate precursors of Impressionism. He shows us that impenetrable black does not exist and that air is transparent." An industrious copier of works in the Louvre and devotee of Chardin, Boudin remained stubbornly independent of the Academy and the establishment. He made his direct, concise paintings of the Normandy coast on the spot, sometimes modifying them in his Paris studio in the winter. Their small size—he often worked in wind strong enough to overturn an unoccupied chair—freshness, and informality found much favor with the vacationing townsfolk he painted, and he died decorated with the Legion of Honor; his retrospective was held at the École des Beaux-Arts, a building that he had never entered.

Monet treasured the months he spent in Boudin's company, working under the open sky, liberated from the dust and gloom of the academic ateliers.

The Seine at Bas-Meudon 1865

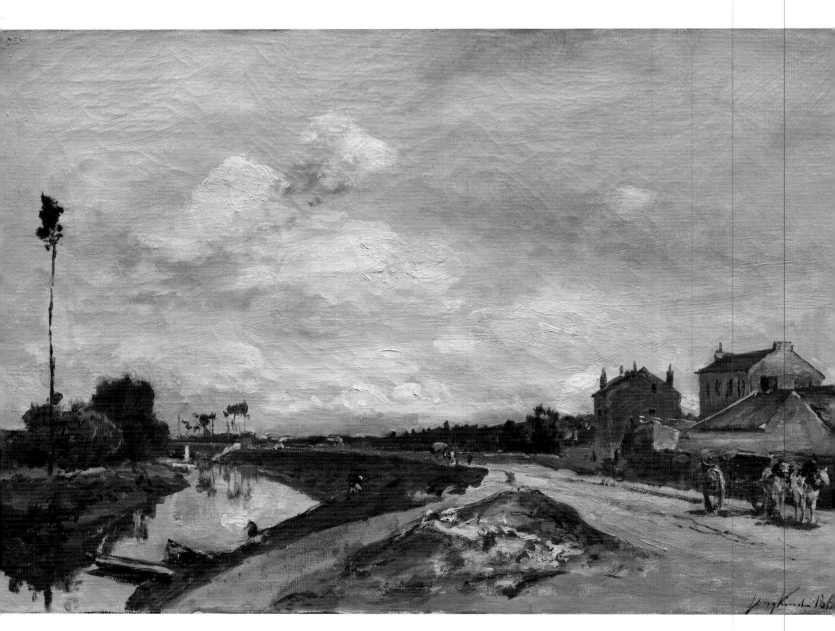

Though prone to depression, Jongkind filled his paintings of the 1860s with light. It was drawn from his outdoor sketches, but it could also have been a reflection of the support of his young Impressionist friends and the companionship of a drawing teacher and her husband, who took him in. The three lived amicably until the husband died, and Jongkind spent the rest of his life with her.

 The young French painters who lionized the moody Dutchman had no use for the fashionable world or academic art. They saw in his work the record of a direct encounter with the world, with light as the theme and the visual field in a single scintillating plane, without the illustrative contrivances of official narrative painting. While Jongkind's 17th-century Dutch sensibility may be seen in his choice of subjects—he manages to make France look like Holland with more sunshine—his aesthetic vocabulary was up to date. Monet referred to him as his "real master."

Spring Flowers 1864

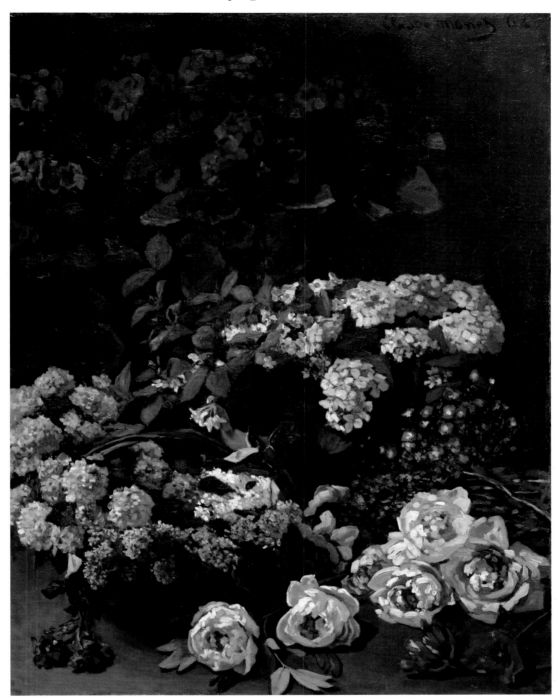

To force him to give up painting, Monet's father refused to pay to exempt him from the military draft. After Monet fell seriously ill while serving in Algeria, his father relented and allowed him to pursue a career in art. Monet was in Honfleur in 1864 when he wrote of his pleasure in the company of his friends and mentors Jongkind and Boudin, his joy in working outdoors ("Nature is becoming beautiful, everything is yellowing, it's becoming more varied, well it's marvelous"), and his pride in an ambitious flower piece that he considered his best work to date.

At 24, his style already had considerable individuality; the full vibrancy of Impressionist color was just around the corner. Boldly designed, confidently and directly painted, this work shows the preternatural alertness to color and the simultaneity of color and brushstroke—the atom of the structure—that were to become one of the foundations of Impressionism.

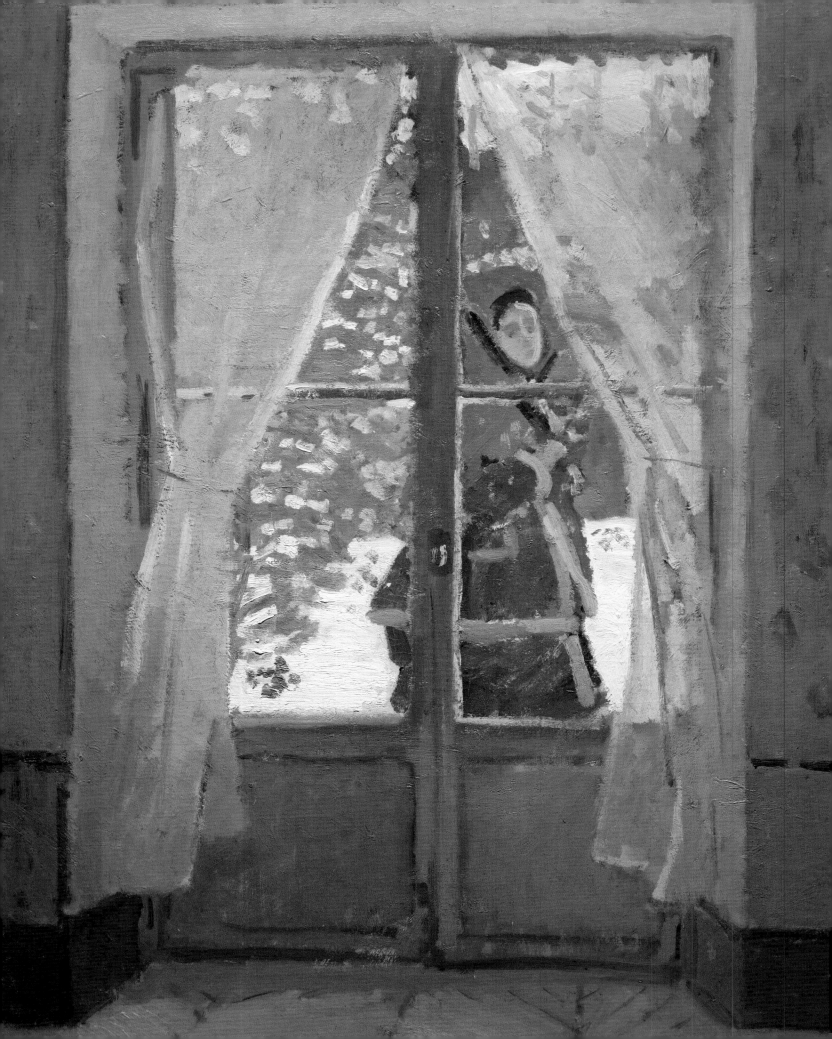

The Red Kerchief: Portrait of Madame Monet 1868–78

Snow was momentous for the Impressionists because their imagery was created directly from nature, and colors behave differently when isolated by white. The range of colors is constrained and each becomes a graphic event like the kerchief in this painting. Furthermore, the infinite inflections possible in the whites, such as blue shadows or the reflection of a pink sunset, have almost the expressive possibilities of flesh. *The Red Kerchief* is an *effet de neige* painting inside out, with the snowscape isolated by the elements of color usually contained within it in the form of buildings, trees, and other landscape features.

Camille Monet's exposure to the weather suggests her fate, to share her husband's hardships but not his fame; she did not live long after this painting was completed. Monet kept it all his life.

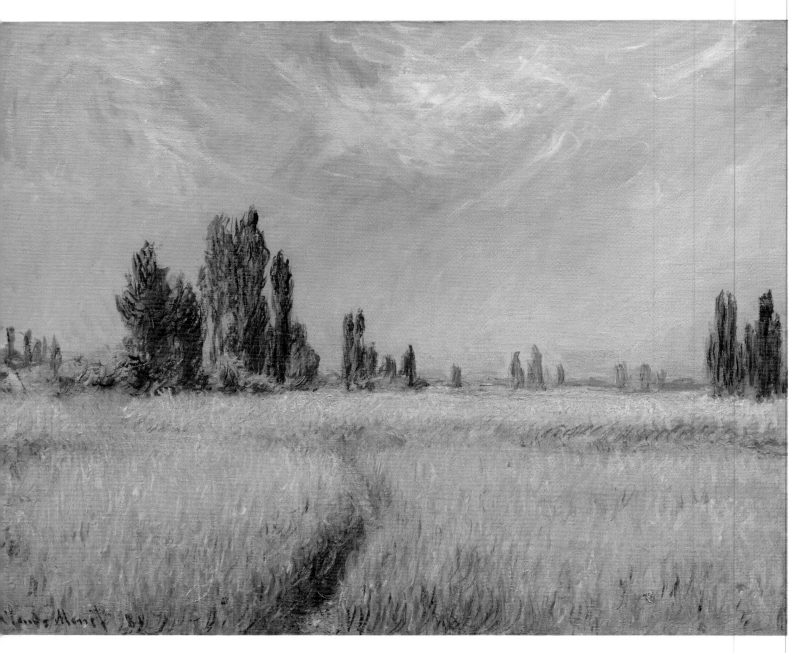

The French dramatist Octave Mirbeau wrote of Monet: "He draws his effects solely from the accuracy of things, set in their own light and surroundings, and from the state of reverie and of infinity that they give to the poet." Mirbeau wrote of this painting when it was first exhibited: "First a field of alfalfa, pale green and almost bleached by the ardent noontime sun, a small path runs through the alfalfa, like a ribbon of gold, then thick, almost pink, wheat rising up like a wall, and behind this wheat, a few dark tree tops. It's nothing, you see, and it is a pure masterpiece; this entire corner of nature exhales a silence, a tranquility, an oppressive heat." Sensation as a subject for art: heat, light, life.

Snapped up by an American collector, this painting has been in the United States for more than a century.

Low Tide at Pourville, Near Dieppe 1882

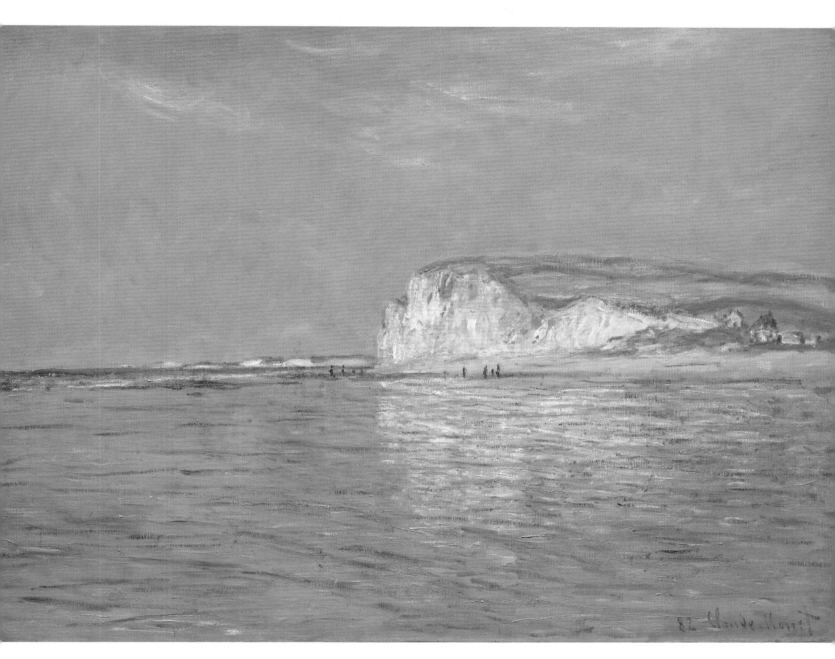

Since 1881 Monet had been living with the family of Ernest Hoschedé, an unlucky speculator who lost his stellar collection of Impressionist paintings to bankruptcy and his wife, Alice, to Monet. In the spring of 1882, with Alice's six children and Monet's two, the couple settled for the summer in Pourville. There Monet began an exploration of the same motif in a series, a procedure that had increasingly preoccupied him since his paintings of the St. Lazarre station a few years before. This time his attention turned to the seashore, the beaches and cliffs near Dieppe.

The stark isolation of the cliff in this work is the result of deliberate design and revision rather than the unmediated contact with nature often supposed to define Impressionism; several objects on shore at the left and some distant hills behind the cliffs have been painted out.

Gardener's House at Antibes 1888

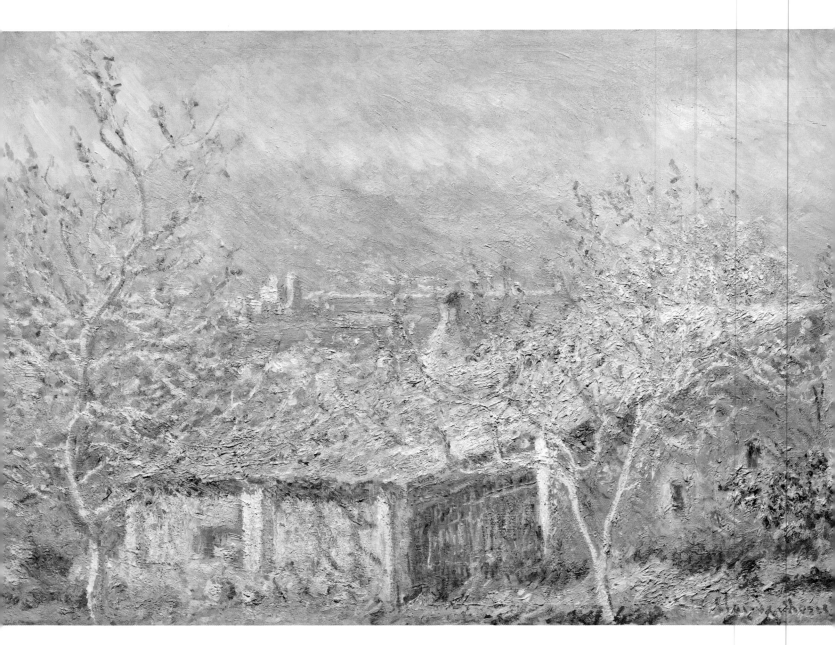

Having practically eliminated black in the 1870s, in the 1880s Monet made his palette still brighter. He began to travel in search of motifs, roaming from the Brittany coast to the Mediterranean. This work demonstrates the unique ability of Impressionist painting to depict color and atmosphere, recreating the brilliant light through the juxtaposition of vibrant warm and cool colors, lightened more than usual by white.

Monet and Alice had lived in Giverny for five years, and, though travel would continue to nourish his imagery, he was already planting the gardens that would furnish the subjects for his career's last and greatest chapter. In these paintings he would create a new kind of landscape and a new conception of pictorial space. But in the painting of Antibes the traditional spatial conventions of landscape linger, though severely eroded by the intensity of the colors.

The Apple Seller c. 1890

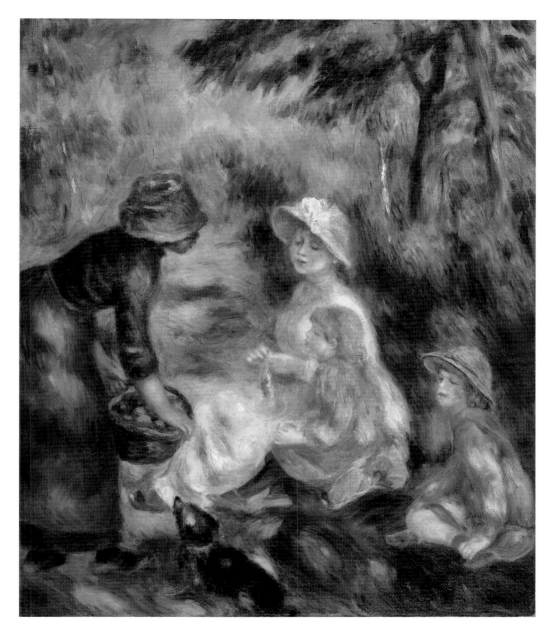

Renoir loved 18th-century French painting, especially the work of Fragonard, who also delighted in vibrant, sensuous life. An 18th-century painter might have placed figures in a landscape in the same way, using a pastoral setting to celebrate the beauty of femininity and innocence. Although he had lived with her for ten years (and the boy at right may be their son Pierre), Renoir had just married the beautiful Aline Charigot, to whom the apple seller offers her wares, and probably made this painting on their honeymoon in Aline's native village. The painting might be seen as a bouquet for her, to celebrate the new chapter in their lives.

Despite its continuity with tradition, the painting is also totally modern in its unified treatment of figure and landscape, the free invention of landscape forms. Form is modeled by high-spirited color.

Water Lilies (Agapanthus) c. 1915–26

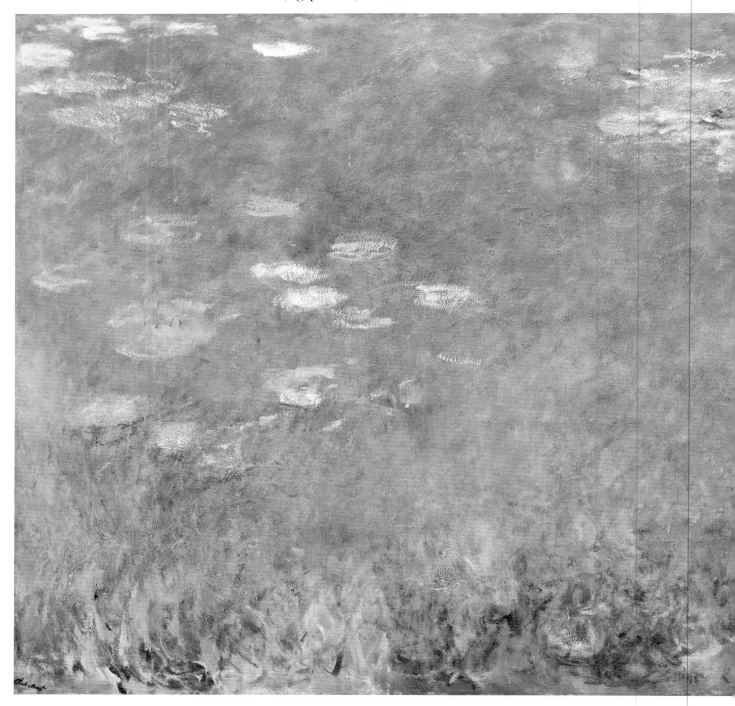

One of a 12-part group, this colossal work represents the lily pond of Monet's garden at Giverny, constructed expressly as a motif for painting. With this work the conventions of Western landscape vanish, as the water's surface, the plants beneath, and the reflected sky become part of a continuous tapestry with scarcely a memory of three-dimensional depth.

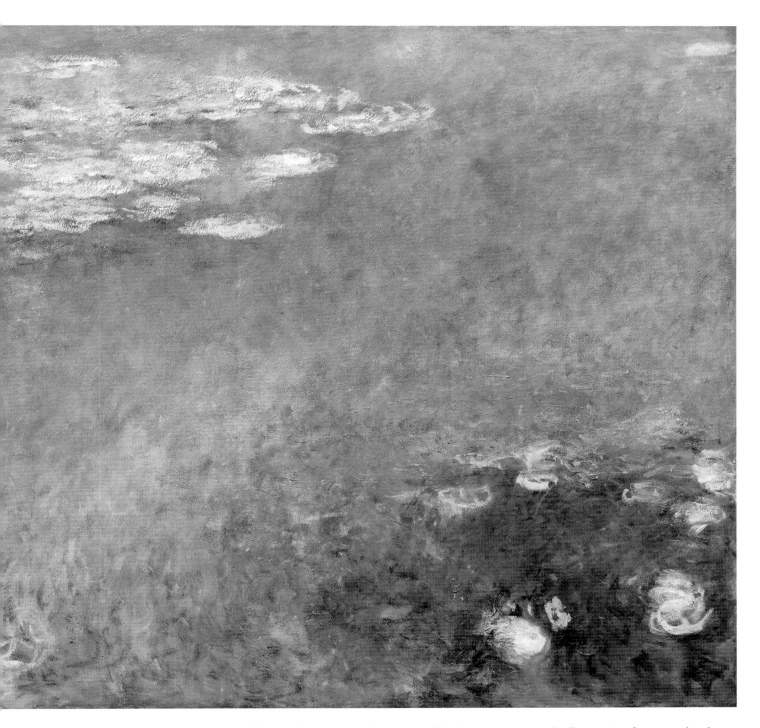

Monet had been advancing into this territory for almost 40 years, gradually merging foreground and background, developing the principal motif into a visual field charged with color that could be connected metaphorically to experience in no way depicted, like the gems, fire, and blood cited in an introduction to Monet's haystack paintings. The water lily paintings consummate a drive toward abstraction that replaced Western perspective with a spatial organization based on color. Abstract painting on this scale would not be seen again before the work of Jackson Pollock and Clyfford Still.

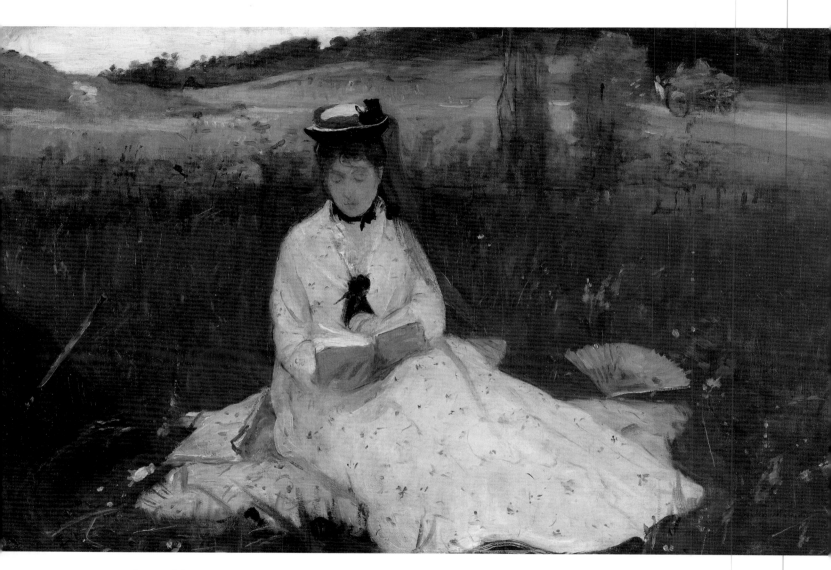

The model was Morisot's sister Edma. They had studied art together, not as a social accomplishment for young girls but seriously, and when Edma married and moved away she wrote to Berthe of her hope that her husband was not aware "of the void I feel without you." In another letter, Berthe tells her sister of a painting by "the tall Bazille" that succeeded in depicting "what we have so often attempted—a figure in the outdoor light." This was a problem that Berthe evidently understood very well, for in this work she achieved a painting vocabulary that unites figure and landscape in a continuous surface as a single optical event, the real Impressionist vision.

The year after this picture was painted, Berthe Morisot married Édouard Manet's brother Eugène. Fantin-Latour had introduced her to Édouard while they were copying in the Louvre, and she posed for Manet frequently before her marriage.

July: Specimen of a Portrait c. 1878

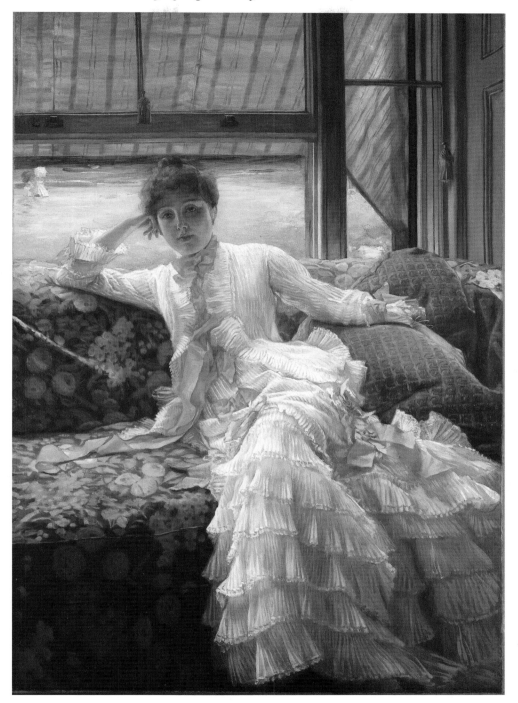

Contemporary and friend of Whistler, Degas, and Manet, Tissot was a very successful painter of the nouveau riche. Born in Nantes, he studied in Paris where he first showed his narrative works depicting modern life. He left Paris for London in 1871 and met Kathleen Newton—his model, muse, and mistress until her death in 1882. After returning to Paris, in 1883 he began a series of large paintings on the theme of the modern urban woman. The end of the century in France saw a revival of Catholicism, and Tissot turned to spiritual subjects for the rest of his career.

This painting is one of four compositions thought to be allegorical representations of the four seasons, for which Newton sat. Here the bright colors, relaxed pose, and the beach glimpsed through the open window create a tranquil mood evoking summer by the sea. Yet a sense of isolation and ennui permeates this portrait of a well-heeled Victorian woman.

Madeleine Lerolle and Her Daughter Yvonne c. 1879–80

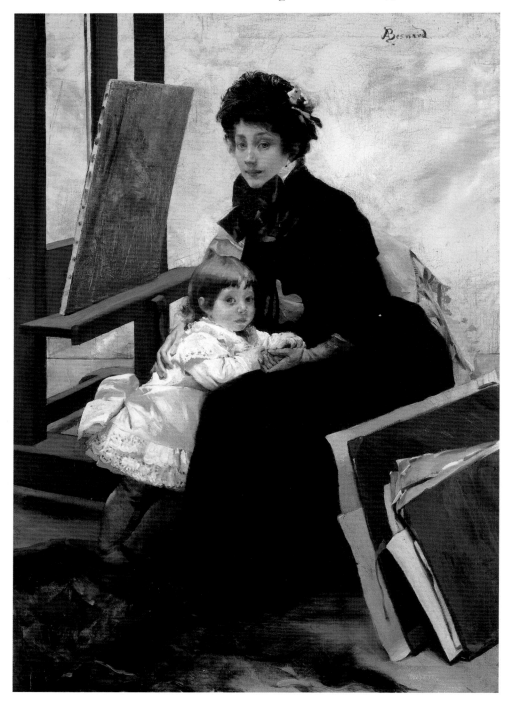

To an artist content to follow well-trodden paths, art could offer a secure career. Besnard's, barely in its second decade when his friend Henri Lerolle commissioned this portrait, was filled with official success. Yet he was far from indifferent to formal innovation, and the shallow space and strong verticals and diagonals of this composition link it to the work of his most sophisticated contemporaries, including Degas.

 The canvas and portfolios are tilted in opposition toward the figures, giving much emphasis to Madeleine's exquisitely painted head. Though a canvas tilted forward was not unusual in a 19th-century studio—to protect a wet surface from dust or facilitate painting while seated—it is a striking feature of this work, with its blank, prepared ground that reminds us of the primacy of painting in the Lerolles' milieu. Its salience is no accident; Besnard spoke of his concern to "express the relationship that they [his characters] have to the world in which they live."

■

Madame Lerolle 1882

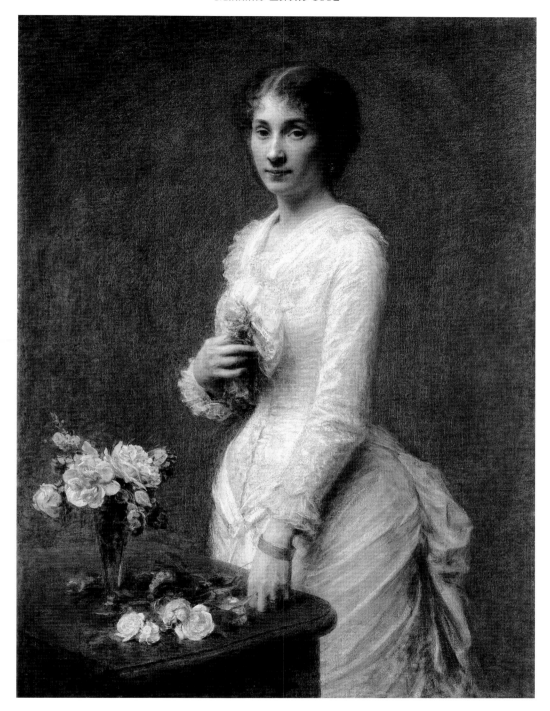

The grave beauty of Fantin-Latour's painting derives from its extraordinary tonal delicacy, a scrupulous vision of form revealed by light and shadow, to which color is applied with a somewhat wary restraint. Indeed, he developed some of his paintings over complete charcoal drawings, which contributes to their tenebrous quality. So does the accumulation of dark colors of varying transparency, thin enough to allow highlights to be wiped through them, that define the essential forms; the paint of the light areas is thicker and more opaque. Fantin's aesthetic conservatism conceals an extraordinarily individual sensibility that transported all his subjects to a shimmering twilight world only he could have invented.

The lovely Madeleine Lerolle attracted the attention of several painters, not least her husband, Henri, a wealthy artist and connoisseur of contemporary music. The couple maintained a salon attended by the foremost musicians of the day.

■

The Lock at Pontoise 1872

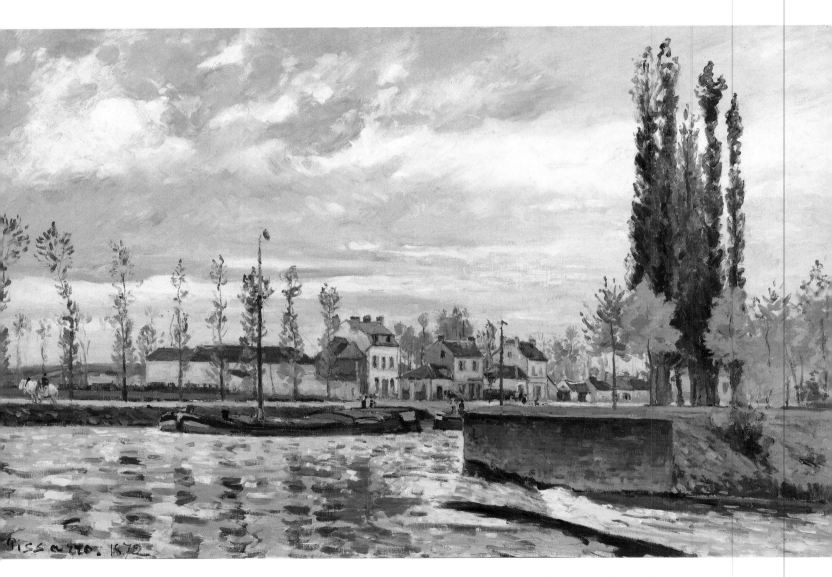

Pissarro's relative maturity would have stood out among the Impressionists even if he had not been a decade or so older. A certain sobriety distinguishes work that, though certainly reflecting the influence of his frequent companion Monet, is somber and composed with severity compared to Monet's contemporary treatments of similar subjects. Pissarro's paintings from the years at Pontoise, both before and after the Franco-Prussian War, stress horizontals, verticals, and rectangular forms, whereas Monet's, often executed at the side of his older friend, are more relaxed, with colors in a higher key, and more urgently painted.

During the war both artists took shelter in London, where they admired the work of Constable and Turner. This canvas, painted soon after Pissarro's return to France, has the simplicity and resolution admired by Cézanne, another young associate, who said that the "humble and colossal" Pissarro had been a father to him.

Edge of the Woods Near l'Hermitage, Pontoise 1879

Pissarro painted this monumental landscape, the largest in his oeuvre, when he was desperately poor and struggling for sales. This audacious statement of his Impressionist principles depicts the backwoods of the Hermitage, a rural hamlet near Pontoise, where Pissarro had been living and striving to perfect a pure, direct vision of nature since 1872. The scene is ingeniously backlit: as we look down a path, reflected light from a house almost forces us to squint to make out the man slumbering in the dense overgrowth.

An artist who never ceased to seek formal innovation, Pissarro daringly eliminated the horizon and restricted his palette to pure hues, applied in systematic diagonal patterns that he compared to knitting. Sensations of space are created by the mere optical vibration of closely valued greens across a shimmering, expansive surface. This enormous canvas appeared in the fourth Impressionist exhibition of 1879 as the stunning summa of Pissarro's landscape of the 1870s.

Frieze of Dancers c. 1895

In the 1880s Degas painted nearly 40 ballet themes using an elongated horizontal format. Of them, this is the most ambitious and daringly abstract. The setting is not defined, as the dancers are surrounded by mere wisps of color, applied so spontaneously that the paint runs and drips. Degas even dashed on the circle in the foreground with his thumb. While perhaps acceptable in a small sketch, such audacious freedom and incompleteness in a six-foot oil painting must have shocked Degas's contemporaries.

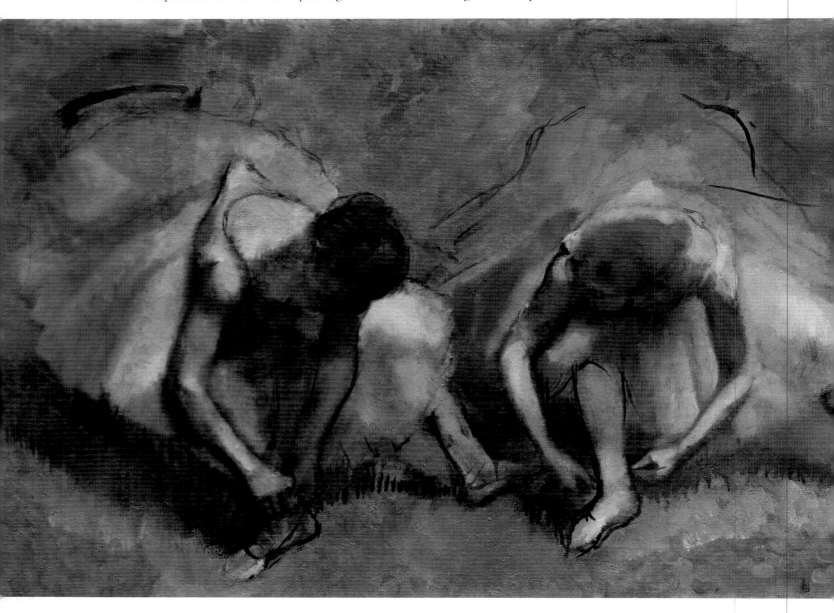

Equally radical is the idea of combining four views of a single figure, thus violating traditional rules of unifying time, place, and (fixed) viewpoint. Showing the dance from different angles, however, generates a spinning motion across the frieze space, which is punctuated by the jostling of complementary color contrasts. Degas's presentation of a single figure seen in several simultaneous actions was probably inspired by the chronophotographs of Eadweard Muybridge.

Dancer Looking at the Sole of Her Right Foot 1896–97

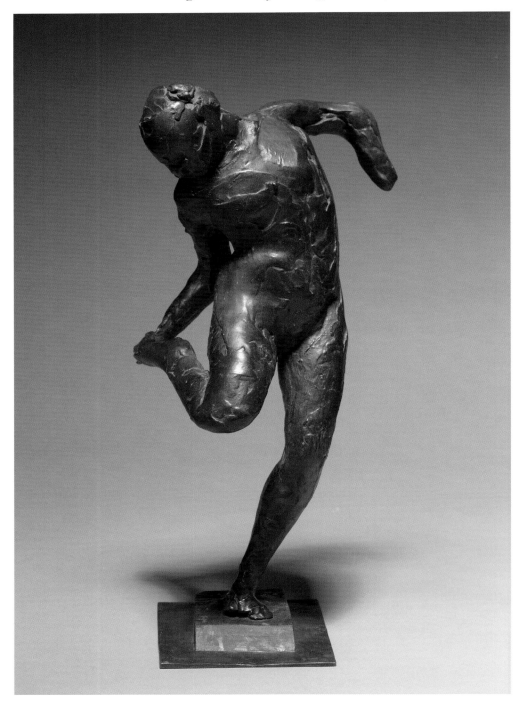

In the painting of his maturity, the varying degrees of finish and frequent marks of hand and brush suggest that Degas was more interested in the process than the product. In his sculpture this inference is even stronger. Though he exhibited only one sculpture in his lifetime, clay and wax models of dancers, horses, and bathers from the latter half of his career were found in his studio, as spontaneous as his paintings, and he enjoyed horrifying a visitor by rolling one into a ball to demonstrate his pleasure in making them. After his death the most complete were cast in bronze.

According to a poem by Degas, the dance instills "something heroic and remote." As a subject it offered him not only classical beauty, but also the awkward beauty of backstage, of the natural choreography of the body in intimate, unposed attitudes that broadened his agenda from the aesthetically privileged world of the ballet to humanity itself.

Mortals, I Am Beautiful

Rodin and Rosso

Thus Charles Baudelaire began a sonnet likening the idea of beauty to the chill perfection of a marble statue "as mute and eternal as matter itself." Baudelaire's Beauty was neoclassical, with a "heart of snow," who abjures any movement that might blur the outline of her form. Published in 1855, this poem might have been inspired by the painting of Ingres or the sculpture of Canova, certainly not the restless heroics of Rodin; yet Baudelaire's divinity addresses mankind exactly as Rodin's sculptures do.

Before becoming Europe's most important sculptor, Rodin failed the exam for the Prix de Rome three times. Resigning himself to work as a journeyman in many decorative trades, he developed his own course of study through enforced independence from the academic curriculum. During several months in Italy studying Michelangelo's sculptures and drawings Rodin discovered his essential subject: the human figure as a vessel for spiritual experience, the supreme expressive instrument.

Rodin's working methods and exaltation of the figure have much in common with academic art, as do his themes and attitude toward his materials, which he treated purely as media, without a modernist's regard for their intrinsic qualities. By the time his work had become widely celebrated younger sculptors already disdained the proliferation of versions in different materials and sizes, prompted by financial opportunity, that dilute the impact of some of his most powerful images. Yet Brancusi, who was familiar with his studio, called Rodin's *Balzac* the point of departure for all modern sculpture and credited Rodin with restoring the human form to its rightful place, with making sculpture human.

Rosso, whose approach to form owes much to Rodin but whose poetic use of materials was entirely his own, felt that the freedom of the *Balzac* was due to his influence, and in truth others found Rodin's reputation oppressive. Brancusi left Rodin's studio after a month, explaining that "nothing grows under the shadow of large trees."

Titans: Support for a Vase c. 1877

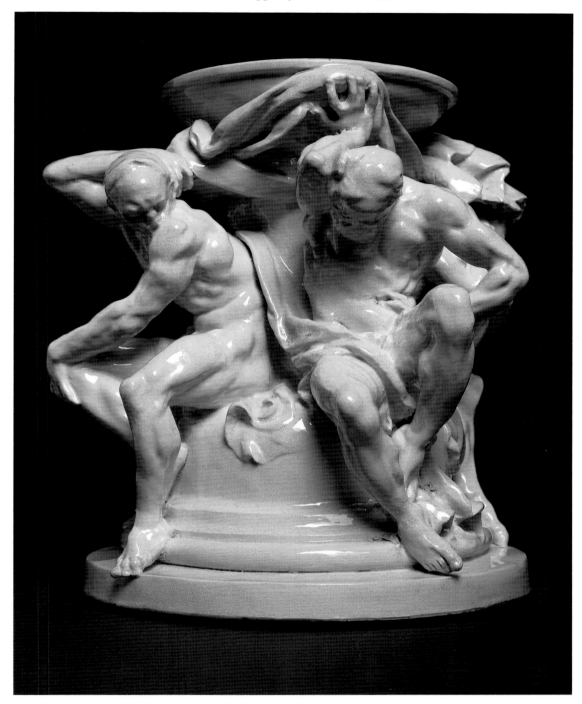

Rodin's trip to Italy brought maturity as an artist, but he had yet to forge an independent career. From time to time he went back to work for Carrier-Belleuse, a talented entrepreneur who had made a good thing of official commissions executed in a slick 18th-century manner. But his atelier was no carriage-trade lounge; many artists collaborated in this bustling, dusty workshop.

Though his aesthetics were conservative, Carrier-Belleuse was passionately interested in new methods and materials, and made a mission of dignifying the industrial arts through traditional imagery, elevating utilitarian objects by the use of the human figure. Many talented young sculptors passed through his atelier, and he gave Rodin a chance to consolidate the influence of Michelangelo. The crouching figures of this object could almost have stepped off the ceiling of the Sistine Chapel, except that their muscular tension is even greater and their poses more rhetorical.

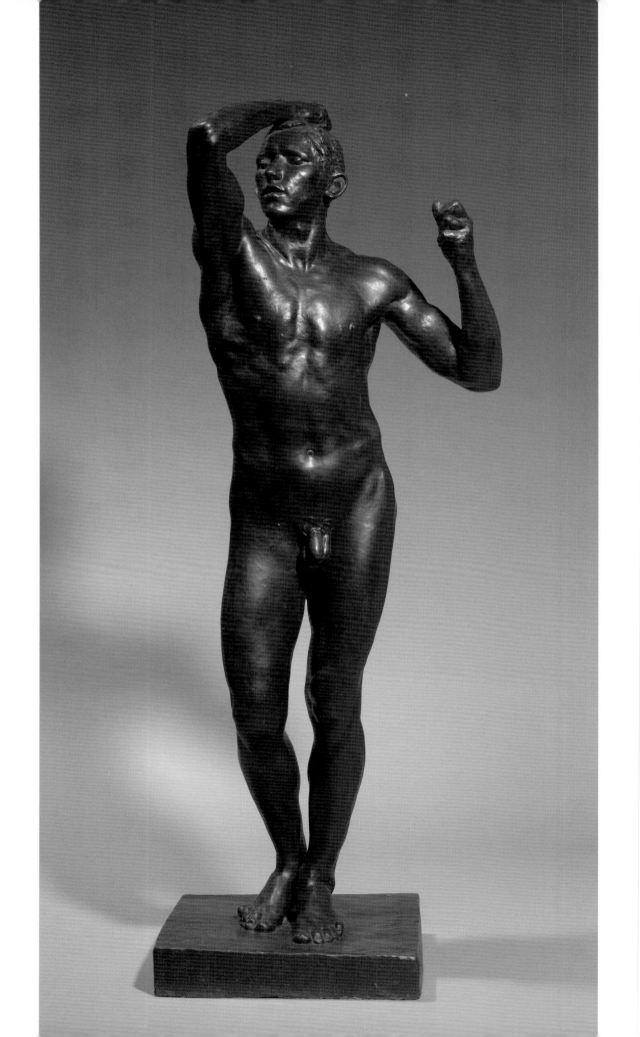

The Age of Bronze 1875–76

Late in life Rodin referred to this work as representing a "slow awakening from a deep dream," and something momentous is indeed awakening: Rodin's style, which became the most influential in Western sculpture. In this work he abandoned the shop-worn iconography of academic art and concentrated, as he would for the rest of his career, on the expressive treatment of the human form as allegory and metaphor.

Work on the *Age of Bronze* was interrupted by a trip to Italy, and the work of Michelangelo supplanted the 18th-century French sculpture on which Rodin had based his early style. Henceforth he would aim for the sublime, and frequently reach it. Some did not believe the compelling realism of the *Age of Bronze* and charged that it must have been a life cast; it took the cooperation of the model in a photographed demonstration to prove that Rodin had used no mechanical assistance.

The Thinker c. 1880

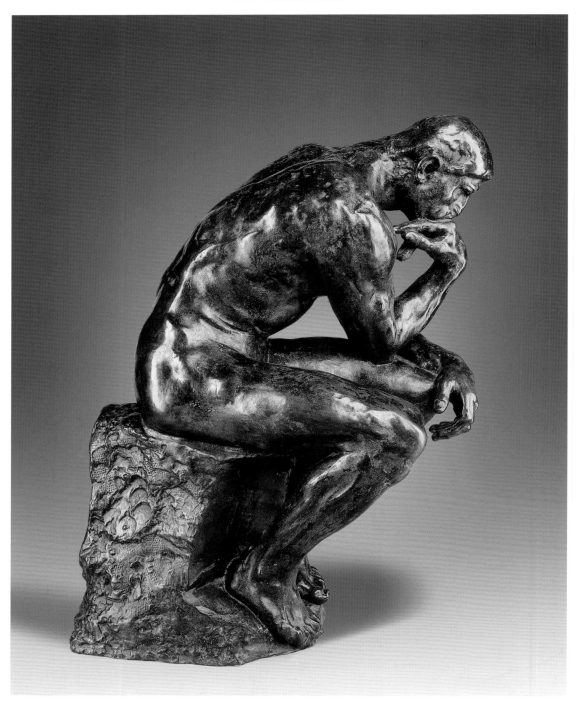

After the validation of the *Age of Bronze,* success came quickly. For a commission for a public museum, Rodin modeled more than 200 figures that writhe in high relief over a pair of gates, inspired by Lorenzo Ghiberti's *Gates of Paradise* in Florence and the *Inferno* from Dante's *Divine Comedy.* Never completed, Rodin's *Gates of Hell* served as a laboratory of figural ideas for the rest of his career, as he gradually eliminated detail in a search for universal forms.

The *Inferno* became a matrix for Rodin's tragic conception of life, a drama in which Thanatos and Eros play equal roles. Many of the groups he invented for the *Gates* were developed as separate sculptures; the *Thinker* derives from a seated figure of Dante that Rodin planned for the tympanum, brooding over the chaos beneath. Its clenched energy may be compared to the charged stillness of Michelangelo's *Jeremiah* in the Sistine Chapel and the figure of *Lorenzo* in the Medici Chapel at San Lorenzo in Florence.

Fallen Caryatid Carrying Her Stone 1880–81

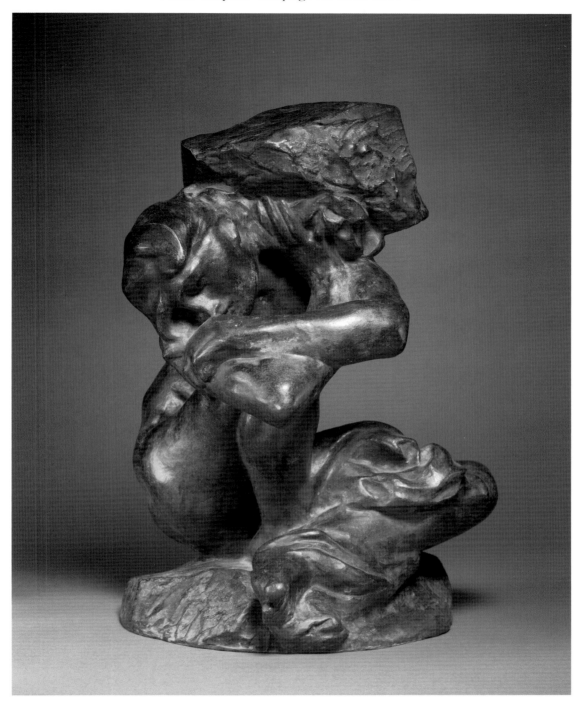

Rodin was wary of allegorical precision, and to an admirer who identified with this figure as courage in the face of crushing adversity he replied, "You may baptize it as you wish." Like many others it found a place on the *Gates of Hell,* at the top of the left pilaster, and a prosperous career as an independent sculpture in different sizes and materials.

Rodin's fans insisted on reading his figures allegorically, and he did not forbid this, but still abjured literal illustration. His goal was the creation of figures evocative enough to strike an individual resonance in each viewer through a search for archetypal, fundamental forms, like a 20th-century choreographer. Their tragic grandeur was his vision of humanity's relation to existence—a metaphorical statement, to be sure, but based on sensation and aesthetic response, not the verbal propositions suggested by titles. Nevertheless, we continue to baptize them as we wish.

William E. Henley 1882

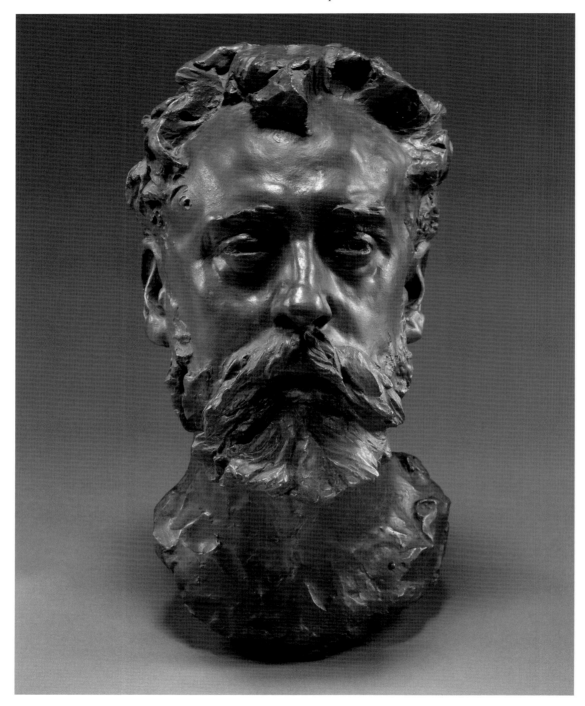

Once established, Rodin was rarely without a portrait commission. Though he did not neglect the individuality of his subjects, who were usually celebrities in their own right, he did generalize their features, recruiting them into a race of bronze demigods that conquered the drawing rooms of Europe. They are modeled so energetically that they seem to be coming to life before our eyes, the marks of his powerful fingers still on them.

In the expressive treatment of this head suggests the stalwart resolve so vivid in Henley's poetry ("I am the master of my fate: / I am the captain of my soul"). Perhaps Rodin was also thinking of the crippled author's triumph over tuberculosis of the bone. Also an influential editor who sponsored Kipling, Wells, and Yeats, Henley had introduced the British public to Rodin, and another cast of this work presides today over Henley's tomb at St. Paul's in London.

Heroic Head of Pierre de Wiessant, One of the Burghers of Calais 1886

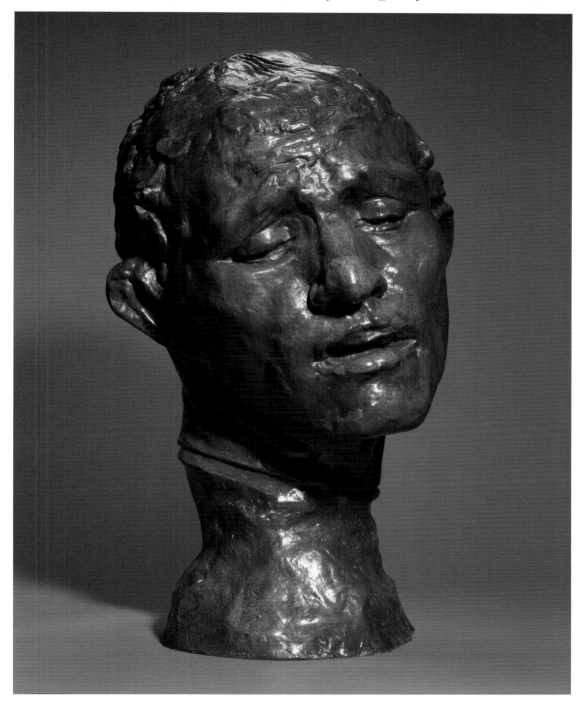

"Depend upon it, Sir, when a man knows he is to be hanged in a fortnight, it concentrates his mind wonderfully." —Samuel Johnson

Separate studies of the burghers' heads and hands became independent sculptures, like this colossal head of Pierre de Wiessant "rich in merchandise and lands," the third burgher to volunteer. A sensitive study for a fictional portrait became a meditation on psychological interiority and introspection; what began as a visualization of a suffering mind in a doomed body may be seen as summarizing the relationship of the mental and the physical.

The burghers of Calais were spared through the intervention of Phillipa, queen of England and a native of their homeland; the city remained in English hands for more than 200 years. Rodin's depiction generated fierce controversy, especially because of his plan to disperse the figures on a plaza where they could mingle with passersby. In a rare capitulation he grouped them together.

■

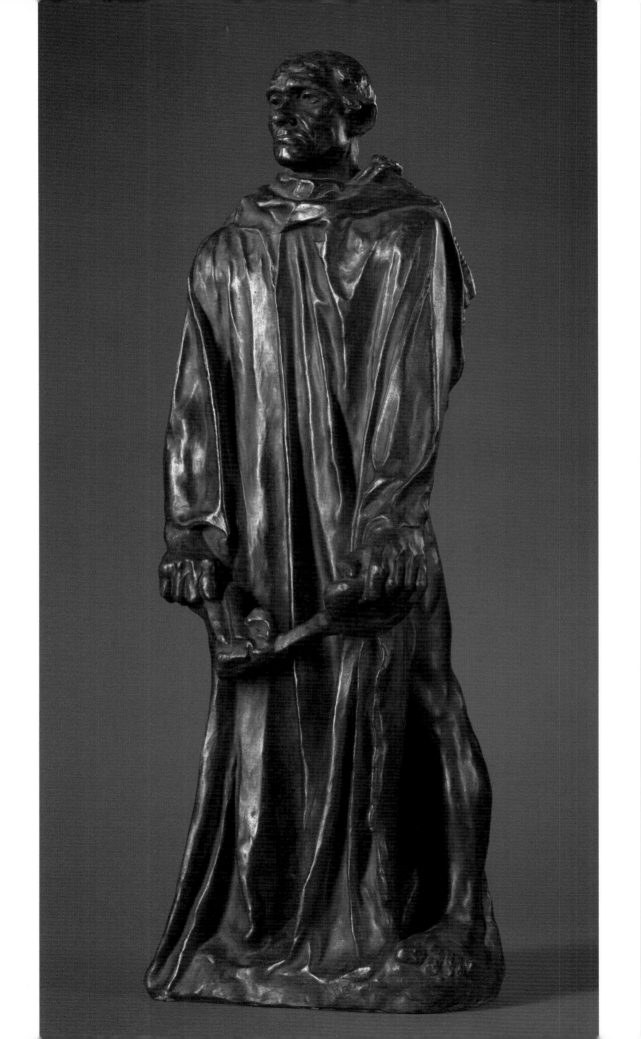

Jean d'Aire 1884

In the 14th century, during the Hundred Years War, six prominent citizens of Calais sought to lift the siege of their city by presenting its keys to the English king. Commissioned to commemorate this event, Rodin conceived a procession of ragged captives in sackcloth with ropes around their necks, as described by the official English chronicler, Foissart. Jean d'Aire, "who had two beautiful young daughters," was the second hero to volunteer.

This version of the figure of Jean d'Aire, reduced in size, shows the major expressive feature of the work: the drapery, developed from nude studies draped in cloth soaked in plaster, which gives it the sepulchral gravity of a medieval tomb and evokes the state of mind of men who believe themselves to be going to their deaths. The deep vertical modeling suggests the perpendicular architecture of a Gothic cathedral, heightened by the play of light over bronze.

Study of Honoré de Balzac 1891–92

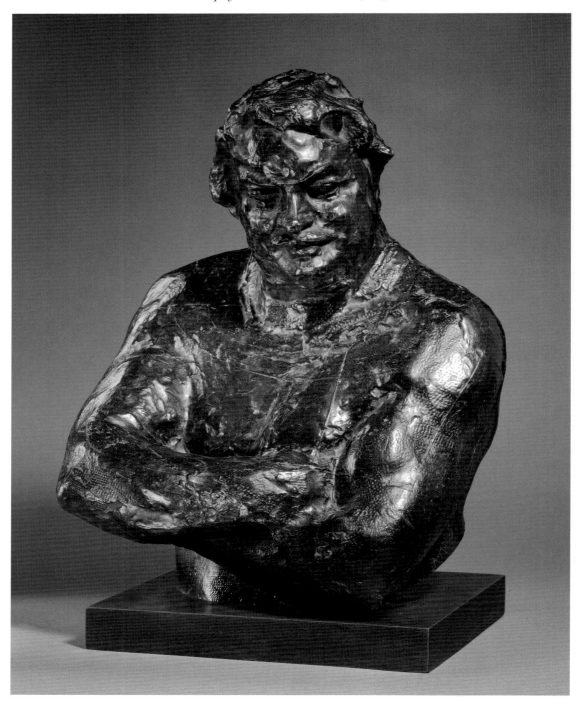

Described by the poet Alphonse de Lamartine as "uncultivated as his genius," the novelist Honoré de Balzac was the author of, among other works, the *Comédie Humaine,* a series of more than 90 linked novels and novellas. He had been dead for four decades when Rodin accepted a commission for a monument to him. The sculptor researched the faces of people in Balzac's hometown and even obtained his measurements from his tailor; over several years more than 40 studies were made.

Finally, a colossal draped figure was presented to the public, and a scandal erupted, provoked by its total lack of illustrative detail: the form, human only at a second glance, seems to be the result of some inchoate natural process rather than an artifact. This study, probably done just before Rodin decided on a standing figure, suggests the final sculpture's elemental power, the result of a search for universal form.

The Fall of the Angels 1890–1900

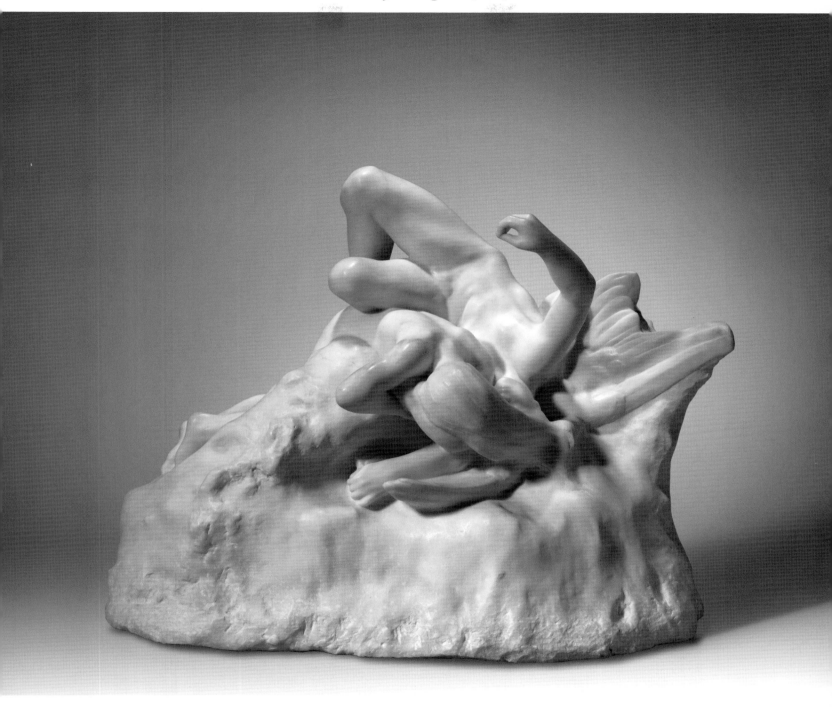

The *Gates of Hell* provided Rodin with a population of figures he could combine into groups unrelated to Dante's poem. In three groups a winged figure falls on another figure, sometimes into an embrace, sometimes on the lower figure's back. Here the lower figure grasps the arm of the falling one, who plunges on his back, head down. Instead of the harsh, sharp modeling of the *Gates,* which suppresses the sexual by the implication of pain, the soft, creamy marble gives this work an erotic glamour, suggesting languor and desire.

Rodin was a satyr in his relations with women, yet his explicitly erotic sculptures are curiously chaste; a rhetorical decorum forbids the intense physicality of the temples of Khajuraho in India, for example, where sexual acts are depicted enticingly. But in sculptures like this one, where sensuality is somewhat sublimated, the powerful erotic current that runs through his work is near the surface.

The Jewish Boy 1892 or 1893

Rosso probably made this work in 1892 or 1893 during several years in Paris. While he knew Rodin and also aimed for a dimension of experience beyond that afforded by literal illustration, the radical individuality of his style was completely his own. His unique approach had the expressive potential of painting, with translucent wax modeled over plaster and forms extended into space with soft, ragged edges, as though some ectoplasmic substance had formed itself in midair. This gives his work the flickering, intermittent quality of life as we experience it, rather than the artificial stasis of the conventional sculpture of his time.

In this work, the delicate wax skin has a subtle, molten animation that suggests melancholy, perhaps tears. Rosso did not use assistants; we see only the work of his hand. He did not aim for editions of immutably finished pieces, but continued to develop his images in different materials, even reworking them in photographs.

Parallel Harmonies

Beyond Impressionism

Art is a harmony that runs parallel to nature—what is one to think of those imbeciles who say that the artist is always inferior to nature?" Thus wrote Cézanne to Émile Bernard in 1897. Perhaps the imbeciles included a few of his Impressionist comrades, whom Cézanne may have considered meek imitators of nature. The remark could serve as a slogan for the experimental schools that we call Post-Impressionist.

Maybe these styles were engendered when Gauguin left his job on the stock exchange to convert his painting hobby into a profession. Restless, frustrated by the slow advent of fame, and usually broke, he formed a habit of traveling in search of inspiration and cheap living. In remote and picturesque Brittany, a group of young artists—our friends Bonnard, Vuillard, and the earnest Bernard among them—began to look to Gauguin as a mentor, and to use the region's ancient landscape and society as a setting for symbolic works that went beyond narrative allegory and visualized primal spiritual situations. The Pont-Aven area of Brittany became a kind of Eden, rendered not as it appeared, but as an imaginative theater for myths decorated in areas of strong, even color, with the flattened perspective of the Japanese prints the artists had recently seen in Paris.

They had also absorbed the work of Puvis de Chavannes, also an inventor of Edenic pastorals, but set in a classical Neverland of his own invention, where few clothes are needed, and the idyllic landscape—with no jarring colors or abrupt contrasts—is all serene horizontals and verticals. A reclining figure lies exactly parallel to the top and bottom of the picture; a raised arm is always parallel to the sides. Trees grow straight up, strategically aligned with other elements of the composition. This was classicism, but it was modernism too, and Puvis had been practicing this brand of Post-Impressionism since before Impressionism itself, never abandoning the Golden Age setting of academic art.

Far to the south, a man whose brief career would become one of history's most famous was creating his own parallel harmonies. Vincent van Gogh dreamed of establishing a community where artists could offer one another mutual support. Learning of Gauguin's privations in Brittany and eager to learn from him, the ingenuous Vincent persuaded his brother, the art dealer, to accept Gauguin's paintings in return for expenses, and the two set up housekeeping together in Arles. This artist's Eden lasted only two months before Gauguin's egoism and van Gogh's mental instability drove the emotionally needy Vincent to violence; he threatened Gauguin, cut off part of his own ear, and presented it to his regular girl at the local brothel. Gauguin fled for Paris the next day.

Study for "Bathers at Asnières" c. 1883–84

Impressionist paintings, the result of a direct encounter with nature, are relatively relaxed in structure; the artist accepts the view that nature offers, though unwelcome features such as industrial buildings were occasionally omitted. But Seurat sought underlying principles and as much internal coherence as possible. He was alert to aesthetic theory and developed an elaborate method with considerable verbal formulation.

Intellectually fastidious and intensely private, Seurat was fiercely proud of his leadership of the avant-garde. He devoted most of his short life to the production of a few major works, for which he made studies outdoors of motifs that were combined in the studio. These tiny panels, broadly painted in brilliant colors and the gestural scale of a 20th-century abstract painting, have a compressed energy, whereas the large works, composed of myriad tiny brushstrokes and tightly organized in many structural units, are monumental and serene.

The Pigeon Tower at Bellevue 1889–90

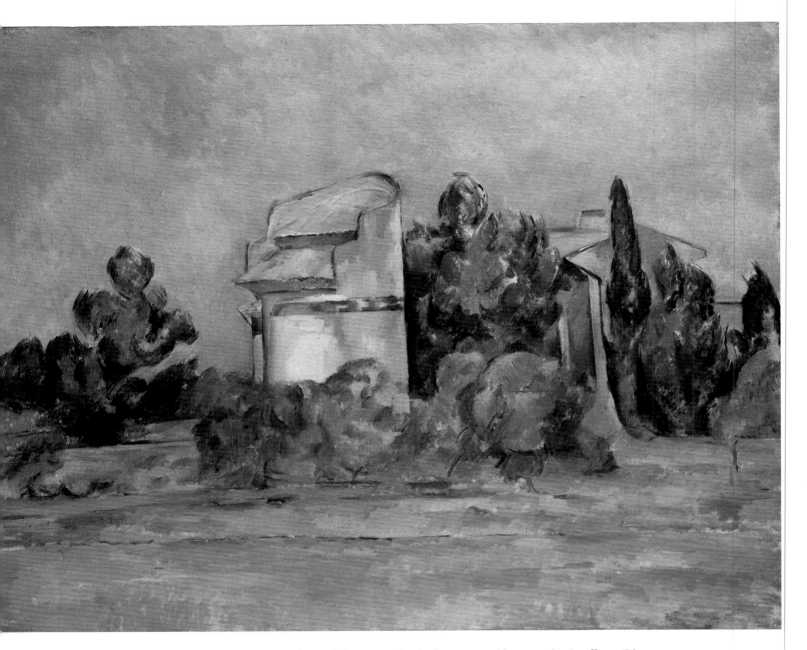

Among the first artists to move beyond the Impressionists' concern with atmospheric effects, Cézanne was more interested in the structure of things. Along with Gauguin, van Gogh, and Seurat, he emphasized two-dimensional elements such as color and line.

In 1889 Cézanne's friend Renoir rented Bellevue, a property in the hills southwest of Aix-en-Provence owned by Cézanne's sister and her husband. Both artists used the pigeon tower as subject matter. Here Cézanne synthesized the various architectural elements by depicting them from different angles. Making the tower the focal point of the composition, he exaggerated its cylindrical shape and extended it upward. By eliminating unnecessary details and presenting the trees as solid objects, echoing the contours of the tower, he followed the advice he had given to Émile Bernard, to "treat nature by means of the cylinder, the sphere, the cone." *The Pigeon Tower at Bellevue* could be one of the paintings that generated the simplified forms of Braque's first Cubist works.

The Pigeon Tower at Bellevue 1889–90

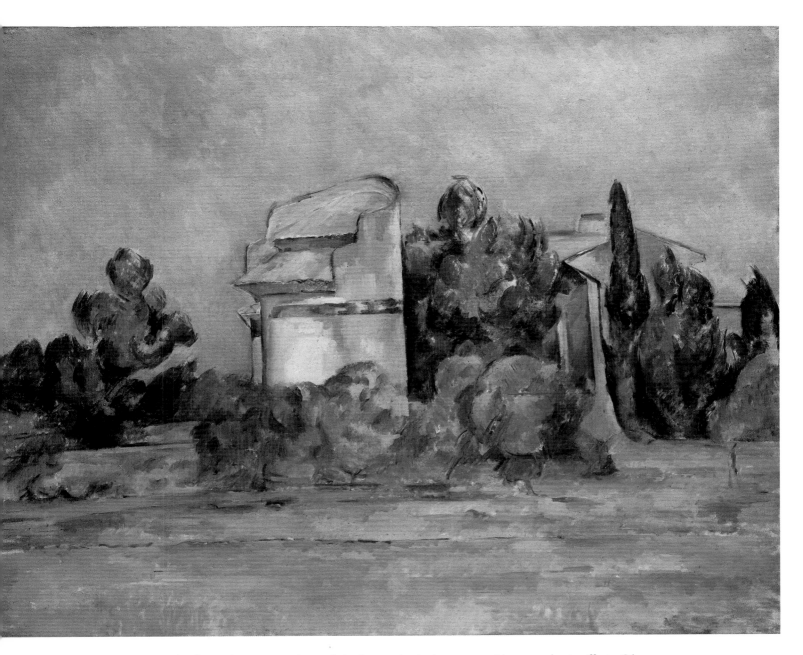

Among the first artists to move beyond the Impressionists' concern with atmospheric effects, Cézanne was more interested in the structure of things. Along with Gauguin, van Gogh, and Seurat, he emphasized two-dimensional elements such as color and line.

In 1889 Cézanne's friend Renoir rented Bellevue, a property in the hills southwest of Aix-en-Provence owned by Cézanne's sister and her husband. Both artists used the pigeon tower as subject matter. Here Cézanne synthesized the various architectural elements by depicting them from different angles. Making the tower the focal point of the composition, he exaggerated its cylindrical shape and extended it upward. By eliminating unnecessary details and presenting the trees as solid objects, echoing the contours of the tower, he followed the advice he had given to Émile Bernard, to "treat nature by means of the cylinder, the sphere, the cone." *The Pigeon Tower at Bellevue* could be one of the paintings that generated the simplified forms of Braque's first Cubist works.

Study for "Bathers at Asnières" c. 1883–84

Impressionist paintings, the result of a direct encounter with nature, are relatively relaxed in structure; the artist accepts the view that nature offers, though unwelcome features such as industrial buildings were occasionally omitted. But Seurat sought underlying principles and as much internal coherence as possible. He was alert to aesthetic theory and developed an elaborate method with considerable verbal formulation.

Intellectually fastidious and intensely private, Seurat was fiercely proud of his leadership of the avant-garde. He devoted most of his short life to the production of a few major works, for which he made studies outdoors of motifs that were combined in the studio. These tiny panels, broadly painted in brilliant colors and the gestural scale of a 20th-century abstract painting, have a compressed energy, whereas the large works, composed of myriad tiny brushstrokes and tightly organized in many structural units, are monumental and serene.

The Brook c. 1895–1900

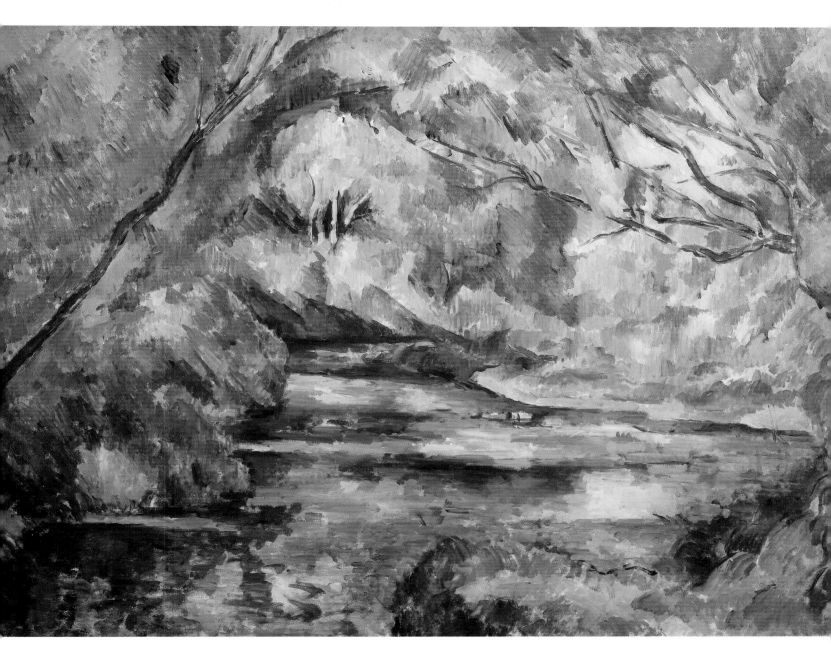

Cézanne had a profound admiration for Pissarro, with whom he painted outdoors in the 1870s. The older artist helped organize the first Impressionist exhibition, and Cézanne participated in the second and fourth exhibitions in 1874 and 1879. Critics ridiculed his paintings, however, and he decided not to exhibit with the group again. He left Paris to live in semi-seclusion in his native Provence, with occasional trips into the city.

In his later years, Cézanne preferred painting landscapes to still lifes and portraits. *The Brook* shows his study of watercolors and recalls Pissarro's depictions of undergrowth. The branches coming into the center form an off-center but solid triangle, and the juxtaposed strokes of color create leaves, bushes, and water through tonal association. The stream meanders into the distance in a series of horizontal planes. The areas of diluted oil paint presage the portions of bare canvas in his late works.

Mount Sainte-Victoire c. 1904

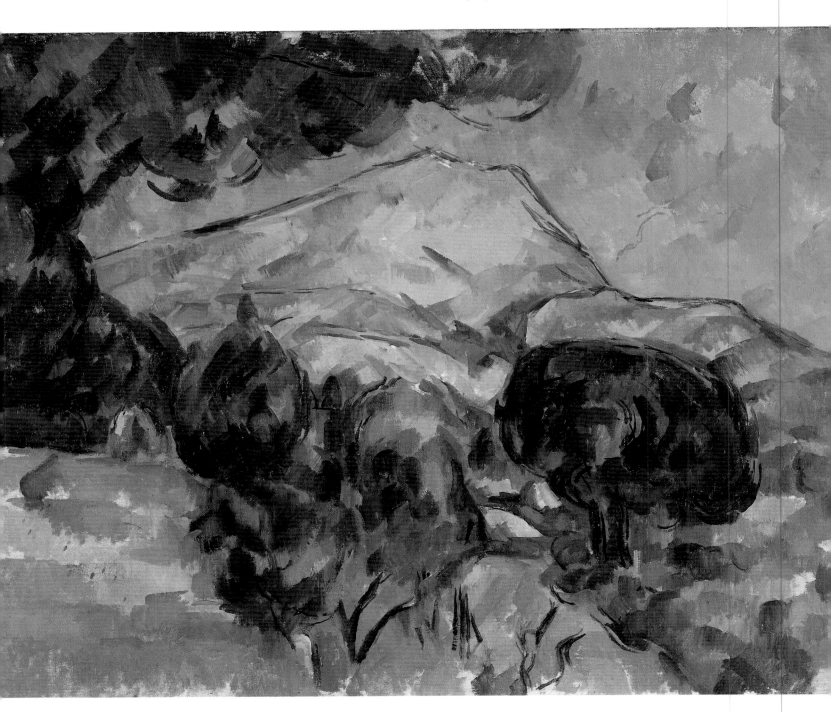

During the last 20 years of his life, Cézanne repeatedly painted the towering mountain of Sainte-Victoire, which lies just east of his home in Aix-en-Provence. The series is considered one of the most revolutionary in the history of art, for in it the artist increasingly compressed space into an integrated configuration of intersecting planes. In this canvas from around 1904, the silhouette of the tree at the left echoes the slope of the mountain, thus uniting foreground and background; the dark tree on the right is flattened, but the pattern of alternating warm and cool colors around this void suggests distance; and the pronounced brushwork enhances the rhythmic organization of space. All Cézanne's principal concerns—to reveal the underlying structure of nature, to evoke spatial sensations by direct color juxtapositions, and to create highly cohesive formal arrangements—are expressed in this view of Sainte-Victoire, the icon of his mature art.

The Poplars at Saint-Rémy 1889

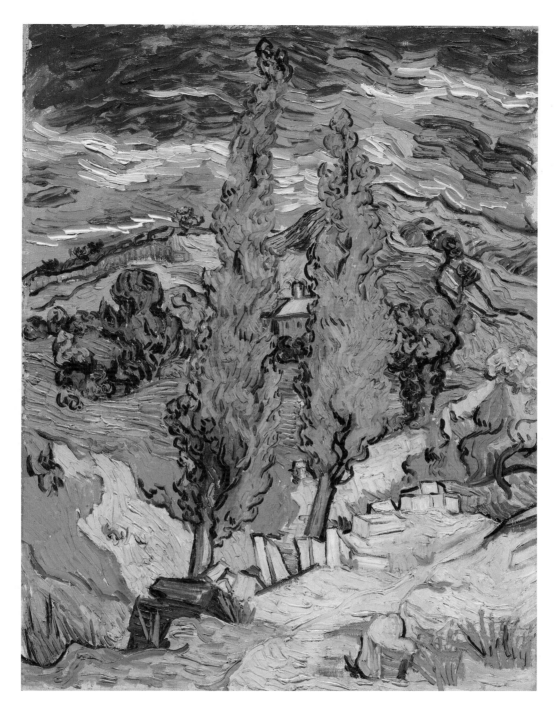

While van Gogh's name conjures a tormented artist, he made more than 800 paintings and even more drawings during his ten-year career. In April 1889, he voluntarily committed himself to Saint-Paul-de-Mausole, an asylum in Saint-Rémy, near Arles. Realizing his attacks were intermittent, his doctor soon consented to brief chaperoned trips outside the hospital. This compelling landscape was painted in October. He referred to it in a letter to his brother Theo: "I have . . . a study of two yellowing poplars against a background of mountains."

The tall trees provide the composition's structure. They twist and lean, generating a dynamism intensified by the diagonals creating the hills. Intense color, applied with heavy, charged brushstrokes, indicates van Gogh's emotional reaction to the subject. The small house at the center is the only evidence of human existence in this cataclysmic landscape.

■

The Large Plane Trees 1889

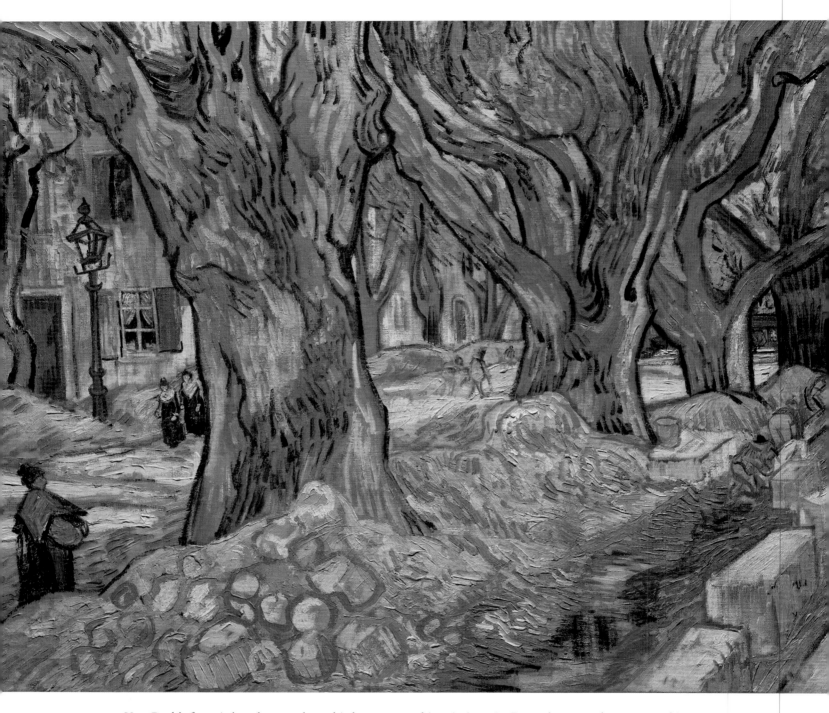

Van Gogh's fame is based as much on his letters as on his paintings. In December 1889, he wrote to his brother Theo: "The last study I did is a view of the village, where they were at work under some enormous plane trees—repairing the pavement." Rushing to capture the yellowing leaves but lacking a proper canvas, he painted on a small piece of linen with a diamond pattern, which still remains faintly visible in some areas. The spontaneous brushwork, coupled with heightened colors and exaggerated forms, infuses the scene with intense excitement. The lives of the road menders and the villagers on their daily errands pale into insignificance beneath the massive trees. Above, the leaves form a canopy of yellow—the color van Gogh associated with eternity—that casts a bright shadow.

The painter often made two versions of a subject, one from nature and one in the studio. The second version of this composition is in the Phillips Collection.

Adeline Ravoux 1890

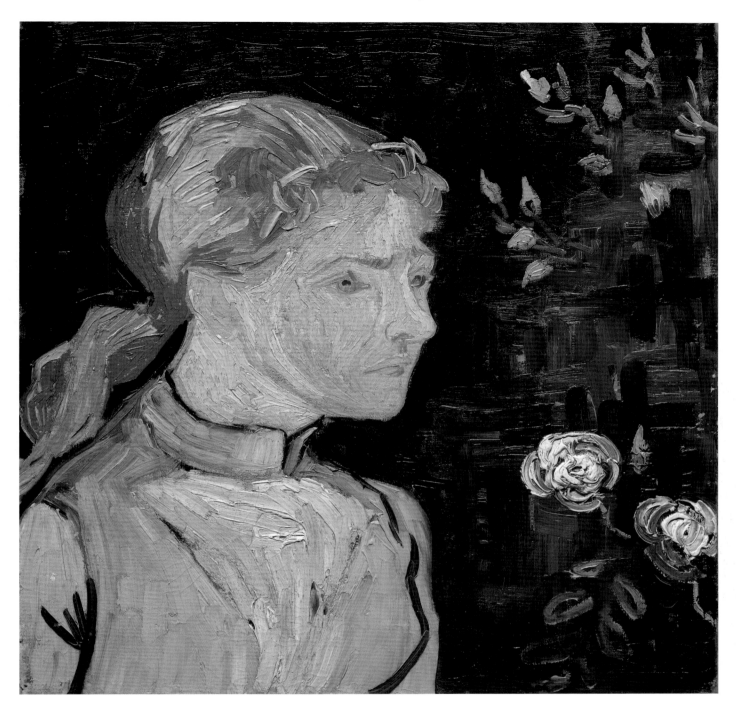

In May 1890, van Gogh left Saint-Rémy for Auvers-sur-Oise, a small town just north of Paris. He found a room at the inn of Arthur Ravoux and, in June, painted three portraits of Ravoux's 13-year-old daughter, Adeline.

Although known for his landscapes, van Gogh's greatest ambition was to paint portraits. "I should like to paint portraits," he wrote to his sister, "which appear after a century to people living then as apparitions. By which I mean that I do not endeavor to achieve this through photographic resemblance, but by means of our impassioned emotions—that is to say using our knowledge of and our modern taste for color as a means of arriving at the expression and the intensification of the character." While Adeline was a young girl when this portrait was painted, photographs of her later in life show that van Gogh presented her as the woman she would become.

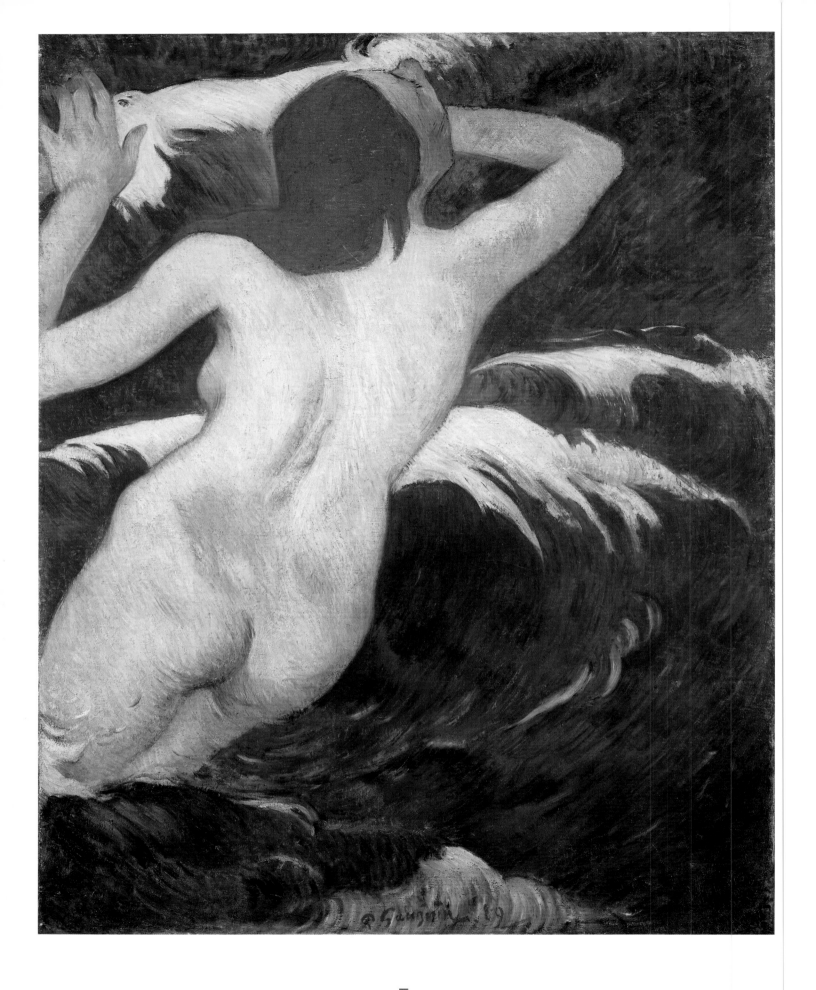

In the Waves 1889

After exhibiting regularly with the Impressionists in Paris in the 1880s, Gauguin decided to distance himself from the movement and in 1886 went to the remote coastal village of Pont-Aven in Brittany, where he lived off and on until 1890. This painting, a seminal work of his Pont-Aven period, reflects his search for an art of primal emotions. Gauguin insisted that artists should not copy nature slavishly, but distort, exaggerate, and intensify experience to reveal its inner meaning. Here he drew with deliberate crudeness, flattening forms and intensifying color with complementary contrasts of orange and green. This "primitivizing" style is wedded to the painting's symbolic content: a naked woman throws herself into the sea (a soul abandons itself to nature). In 1889 *In the Waves* appeared in what is considered the first exhibition of the Symbolists—a group of artists whose works explored dreams, fantasy, and the realm of the imagination.

The Large Tree 1891

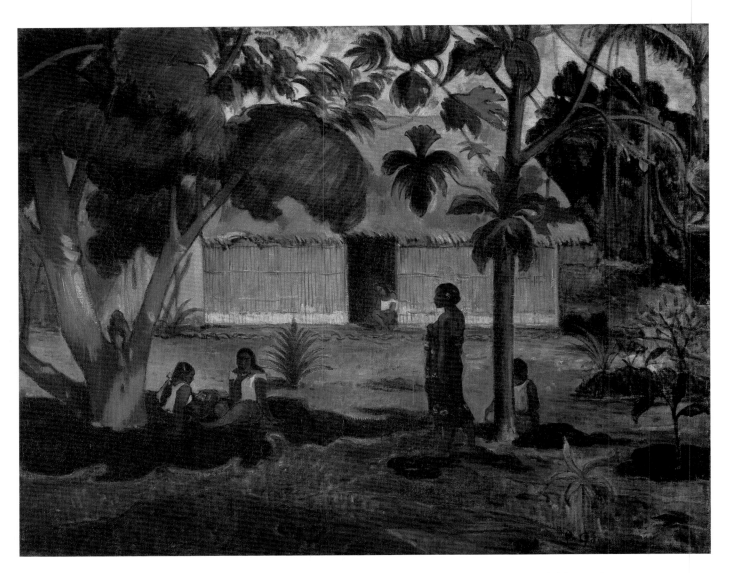

In 1890 Gauguin was at a decisive point in his life. He had not seen his wife and five children, who were living in Copenhagen, since 1885. Disgusted with the decadent civilization in which he lived, he used the proceeds from a sale of his paintings in 1891 to finance a trip to Tahiti. His first stay on that Polynesian island lasted two years, and he worked on some 30 paintings, seeking to capture the expressive and magical qualities inherent in Tahitian art. He wrote: "I have escaped everything that is artificial and conventional. Here I enter into Truth, become one with nature."

This canvas is among the first paintings he completed in Tahiti. The simplified forms and rich colors were intended to be both symbolic and mysterious, evoking private thoughts and emotions. "I obtain symphonies," he wrote, "harmonies that represent nothing real in the absolute sense of the word."

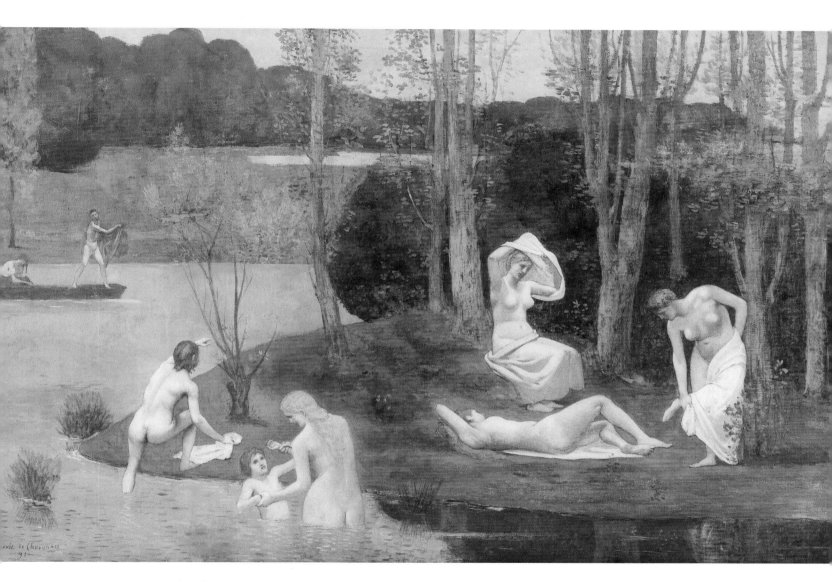

Puvis de Chavannes, essentially a self-taught artist, developed a poetic style of simplified, flattened forms in the classical tradition that influenced Gauguin, the Symbolists, and later Picasso. The frescoes at Pompeii and Piero della Francesca's *Legends of the True Cross* in Arezzo inspired Puvis to take up mural painting. His commissions include works for the Sorbonne and Panthéon in Paris, and the Boston Public Library.

Puvis was asked to devise two murals, *Summer* and *Winter,* for the Hôtel-de-Ville (city hall) in Paris. *Summer* was designed for a wall broken by a doorway. The Cleveland painting is not a study for the mural but a smaller, later version of the scene without the disruptive doorway space. By merging the groups of nude figures on either side of the doorway, eliminating background figures, and changing landscape elements, Puvis created a more tightly configured and intimate space while preserving the carefree languor of a summer afternoon.

Eva Meurier in a Green Dress 1891

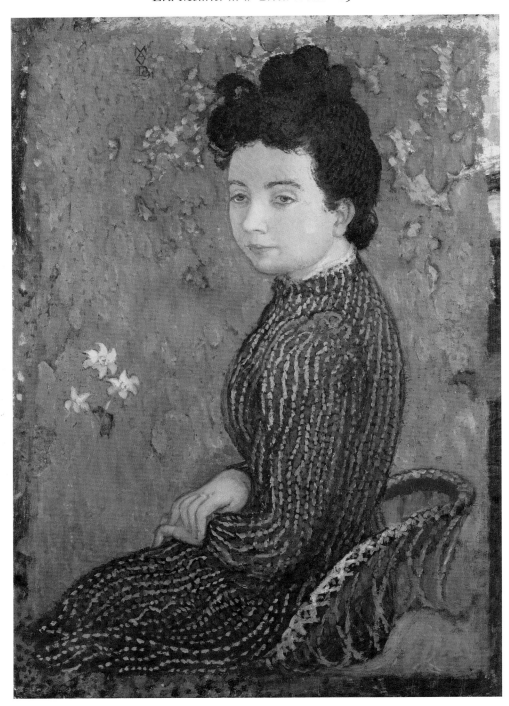

Denis rejected the naturalism of his teachers and followed Gauguin into the enchanted forest of Symbolism. Much of his work is narrative, poetic fables in pictures. He alertly appropriated avant-garde styles: the sinuous curves of art nouveau, the shallow space of Japanese prints, and the dots and broken color of pointillisme.

Also an influential theorist and critic, Denis laid the foundations of much modern criticism with his declaration that a painting is primarily "a flat surface on which colors are applied in a certain order." Yet the radicalism of the young Denis gave way to increasing conservatism, especially in politics. A devout Catholic, he executed major commissions in religious and secular settings.

In this portrait of the young woman who was to become his sister-in-law, the face and hands—whose curiously insistent attitude may bespeak her vocation as a pianist—are painted smoothly, but the rest of the surface shimmers with dots of sensuous color, like brocade.

Portrait of a Woman C. 1891

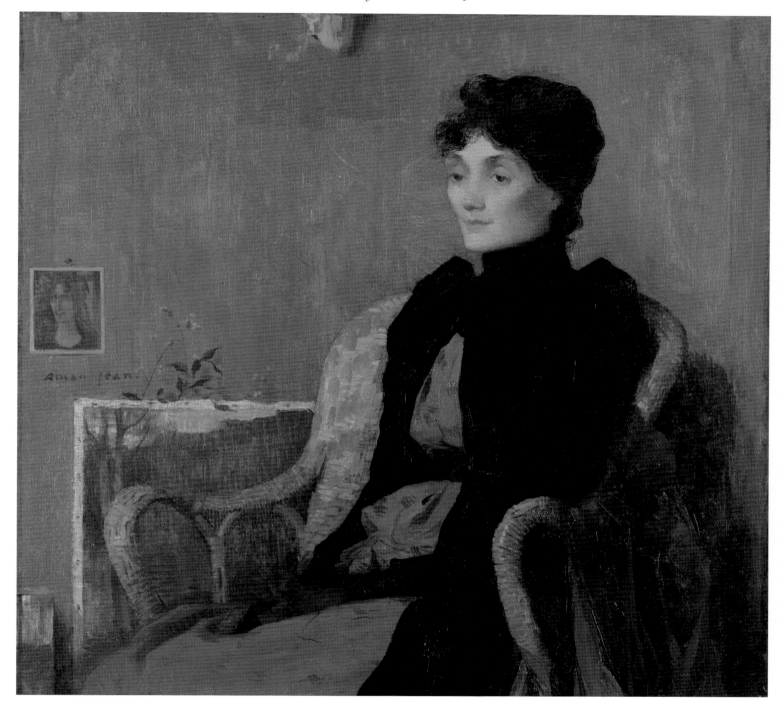

Each generation of artists, already too familiar with the work of their predecessors, seeks to experience a fresh reality. Even while the Impressionists reigned in exhibitions and galleries, a group of younger artists began working within a broad movement in 19th-century European art, summarized by Baudelaire: "Reality itself is only found in dreams"—dreams of the legendary past, dreams fostered by the mood projected by a work of art.

Though Aman-Jean also painted narrative works that resemble those of the English Pre-Raphaelites, this portrait, like most of his work, is essentially an illustration of mood, a painting whose sad, dreamy subject invites our own melancholy reflections. An admirer of the Symbolist poets Mallarmé and Verlaine, Aman-Jean's style followed the arc of influences from Puvis to Bonnard. His work is a somewhat theatrical representation of a realm of mystical, subjective experience, often exemplified by the figure of a woman.

Under the Trees 1894

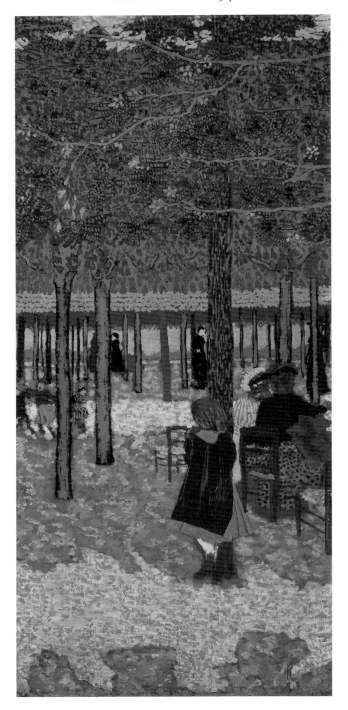

Fin-de-siécle Paris lives in the work of Vuillard and Bonnard. Vuillard's visual experience included the patterns and colors of his mother's dressmaking materials, experiments with the Nabis, a group of young artists who rejected Impressionism's purely optical response to nature, and painting decors for the avant-garde theater; his head was full of the poetry of Mallarmé and Verlaine.

One of a group of panels that decorated the dining room of a modish apartment, this painting is typical of the way Vuillard painted during the century's last decade: flat areas of contrasting, almost complementary color close in value; a pictorial space as shallow as a Japanese screen; and a dry, matte surface worked in a leisurely, deliberate manner. Design and color rule. Part of the room's architecture, the Public Garden panels are like windows through which Paris has Vuillard's sense of order, design, and the splendor of daily life.

■

Pine Tree c. 1897

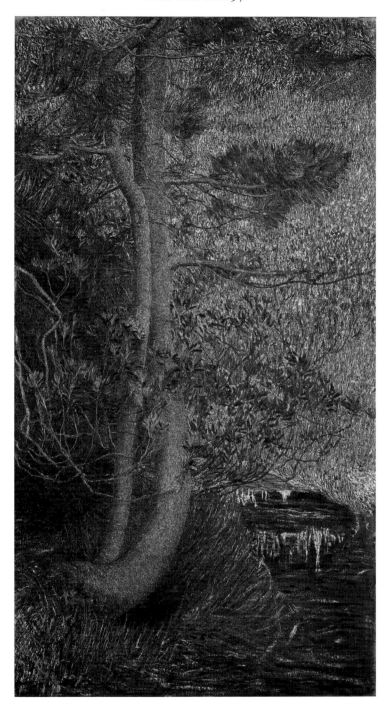

Segantini's distinct technique is characterized by brilliant colors applied in parallel strokes to create an unusually vibrant surface. He was one of the proponents of Divisionism, the Italian version of Neo-Impressionism. Born in Italy, Segantini spent the last ten years of his short life in Switzerland, where Symbolist artists and writers numbered among his friends.

 This composition—forest vegetation across a brook from a lush alpine meadow—has traditionally been thought a study for a larger work or considered unfinished because the cascading brook at the lower right seems to disappear into the earth-red layer of primer. Segantini may have intended the twisted and bent pine tree, struggling to survive in a harsh environment, as a metaphor for human perseverance. As he wrote, "The red rhododendrons proclaim eternal love, eternal hope is the answer of the evergreen pine . . . living water flows out of the living rock, both symbols of eternity."

Café Terrace 1898

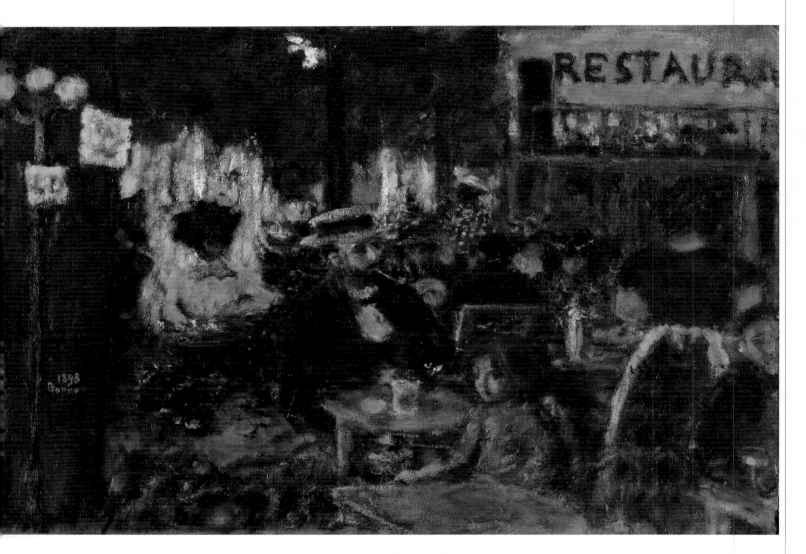

In this work the subject is not the café characters Toulouse-Lautrec would have noticed, but urbanity itself—the vibrant life of Paris's Golden Age, where Bonnard and Vuillard passed their youth in the adventures of Symbolism, Post-Impressionism, and the literary and theatrical avant-garde. The terrace of a working-class restaurant is filled with luminous shade, a cool oasis brightened by the hot sun flooding the boulevard beyond. In this floating world everyone, old and young, is welcome.

Bonnard's preference in the 1890s for dark figures against light backgrounds may reflect his love of the shadow plays then popular in Paris cafés. The theater nourished his art in other ways, too, prompting him to find ways of dramatizing meaning visually without literal illustration, through pattern and color, which tremendously expanded his expressive vocabulary after his involvement with the theater came to an end.

Café Wepler c. 1908–10, reworked 1912

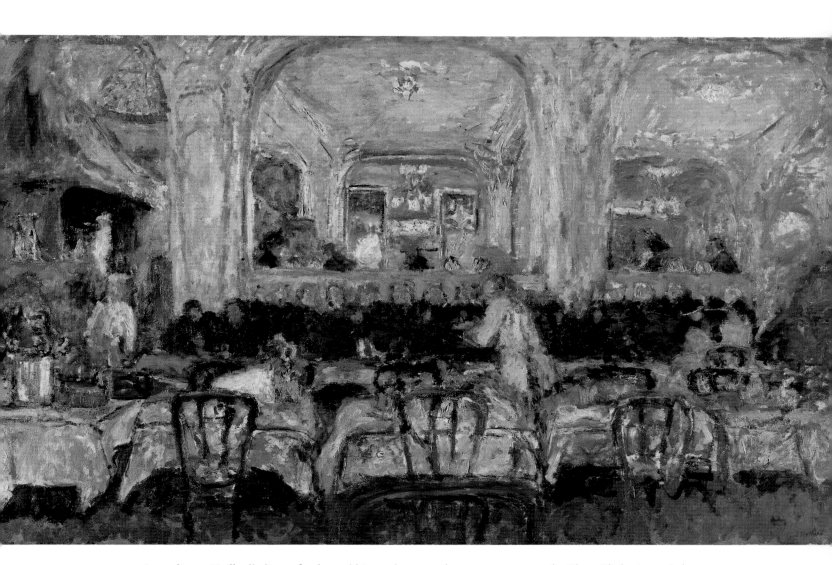

According to Vuillard's diary, after he and his mother rented an apartment near the Place Clichy in 1908 they went to the Café Wepler for a beer to celebrate their rediscovery of the neighborhood. Years later, when their apartment building was sold for demolition, Vuillard wept to see it destroyed. But Wepler's survives. Léon-Paul Fargue, an affectionate poet of Paris, described this huge café "as big as an ocean liner" and as "gentle to all and sundry souls," and many of the souls wrote about it. Vuillard's is the most distinguished visual attention it received.

With the expansive space of a landscape and without the psychological tension generated by the mysterious figures and insistent patterns of his early interiors, the spatial format and elevated mood of this genial painting have much in common with decorative panels like *Under the Trees*. So relaxed is the brushwork, it could almost be the work of Vuillard's close friend, Bonnard.

Vase of Flowers c. 1905

Redon was of the same generation as the Impressionists, but he turned to mystery, imagination, and emotion in his art. Gauguin, a fellow Symbolist, wrote of Redon's art: "His dreams become reality through the probability he gives them. All his plants, his embryonic beings are essentially human, have lived with us; they certainly have their share of suffering. . . . In all his work I see only the language of the heart."

In his early work, mainly graphics in black and white, he created a shadowy world with strange human and plant forms; a botanist was among his important early mentors. Later in his career he worked in luxuriant color, and in this painting his knowledge of botany is allowed to inform the sensuous form and heightened luminosity of the flowers. In this way he fulfilled his ambition of conveying nature not objectively but "flowers as they are seen in dreams."

The Dessert, or After Dinner c. 1920

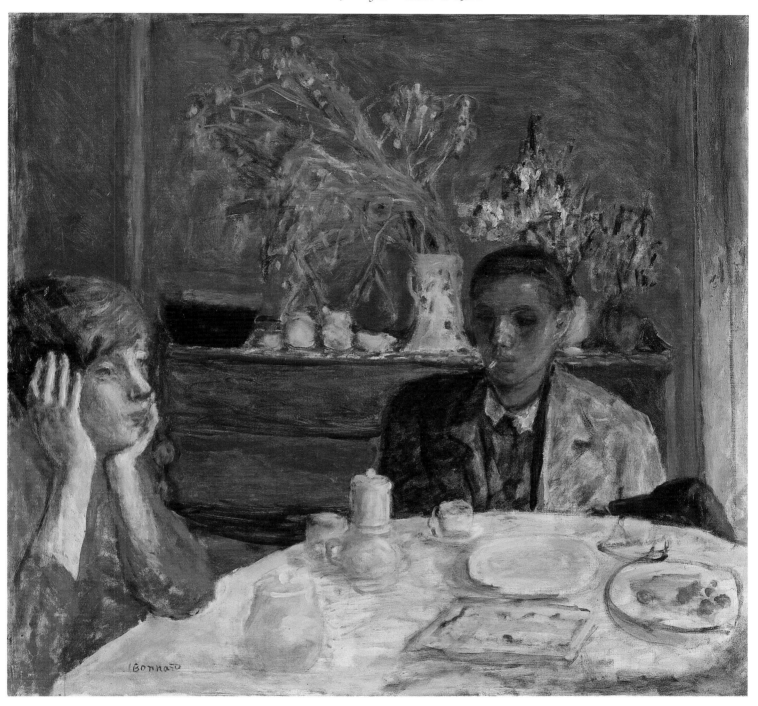

By the 1920s Bonnard had created a style in which color is the primary instrument of meaning. Shadows filled with color have advanced to the front of the picture plane, a continuous surface where everything, near and far, takes place. The method of the Impressionists has been appropriated to weave a tapestry of color that creates an irradiated, alternative reality, usually a vision of the artist's domestic life in which light itself has been made to represent not objects, but nostalgia, memory, desire.

Most of these paintings feature his wife, Marthe. Though older than Bonnard and unpopular among their acquaintances, she nevertheless must have been an efficient muse; the erotic charge she brought to his work never entirely faded, and for more than 40 years, even after her death, she remained young in every painting. Here she is accompanied by Ari Redon, son of Bonnard's friend Odilon Redon, who had died about four years before.

The Road to Nantes 1929

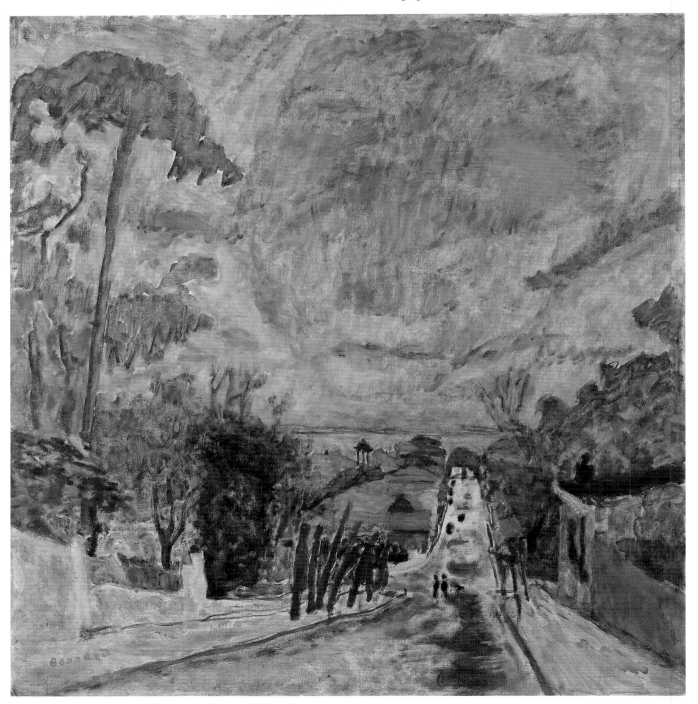

Bonnard wrote that he discovered color in the south, at Saint-Tropez, but once discovered it appeared everywhere, even on the road to the green and gray Loire valley. Marthe's health was fragile, and the couple traveled often from spa to spa. He liked travel, and friendship with Monet had stimulated an interest in landscape. The old Impressionist convinced him that art really sprang from delight in nature, and Bonnard began many days with a walk and a sketchbook (this very view would appear again in a sketchbook, two years later).

Monet had just consummated his transformation of Impressionism into monumental abstraction, but for Bonnard the Impressionist idiom was personal, even intimate. Perhaps refreshed by the liberation felt when setting forth on a journey, this work is more emotionally relaxed than his interiors, where the indoor drama of family life is illuminated with blazing outdoor light.

Surprise Me

Picasso and the Avant-garde

In 1912 the Russian ballet impresario Diaghilev, impatient with the boastful talk and conservative scenarios of the young poet and dramatist Jean Cocteau, commanded, "Surprise me! I'm waiting for you to surprise me!" Whenever he told this story, Cocteau credited Diaghilev with prompting him to write the epochal ballet *Parade,* with decor by Picasso and music by Erik Satie, a seminal event in the history of modernist art.

We owe the ubiquity of the avant-garde—fearless scouts riding ahead of the main army—to the century covered by this exhibition. Change and development had always been recognizable, but not until the late 19th century did people come to expect a few artists to form a cutting edge of innovation, a role that became a constant in society's general concept of art as an enterprise. The explosion of new styles in painting and writing during the Belle Epoque and the adventures of Fauvism and Cubism fostered an appetite for novelty that accelerated innovation through the 20th century.

Picasso, continually reinventing himself, was the perfect standard-bearer, but the exhibition displays the experimental daring of many others. The momentum generated by Kupka's mystic union of color and form, Arp's discovery of the power of chance as a design tool, Brancusi's drive toward the elemental, Matisse's paradise of color, and Surrealism's agon of introspection may still be felt today, when innovation is no longer confined to imagery. Media, method, meaning—the works—must not cease to change. Since the Impressionist revolution, novelty earns respect.

The Artist's Sister Lola c. 1899–1900

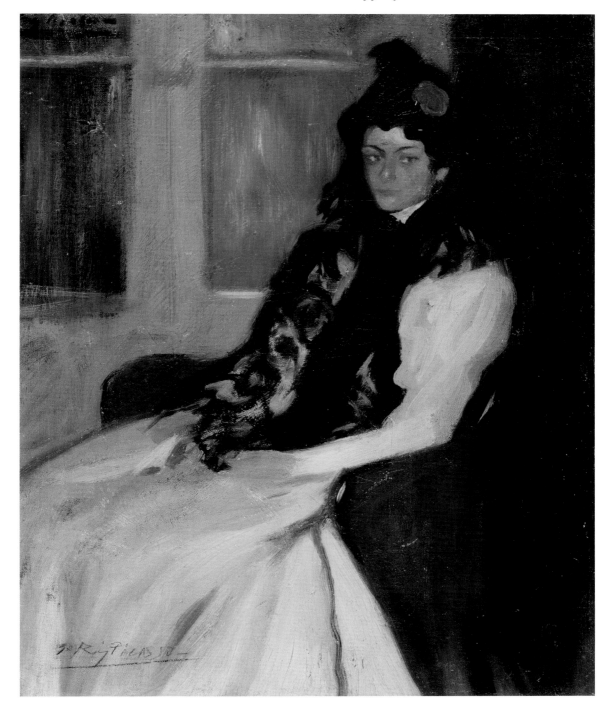

First studying with his father, Picasso copied classical images and then advanced to drawing and painting from life and studying perspective. At 14, he entered the senior course at the Escuela de Bellas Artes in Barcelona, quickly mastering the academic techniques taught there; he then attended the Academia de San Fernando in Madrid for a few months and by 1898 had abandoned all formal training. After returning to Barcelona, he found a studio and was soon associating with artists who had more modern ideas about art.

 Picasso painted this portrait of his sister Lola when he was 18 or 19. Among his favorite subjects, she appears in eight paintings and more than 30 drawings over the years between 1895 and 1900. The evocative colors and barely suggested forms are characteristic of the romantic style prevalent among the modernista and reflect Picasso's early interest in the paintings of El Greco and Edvard Munch.

■

Woman with a Cape 1901

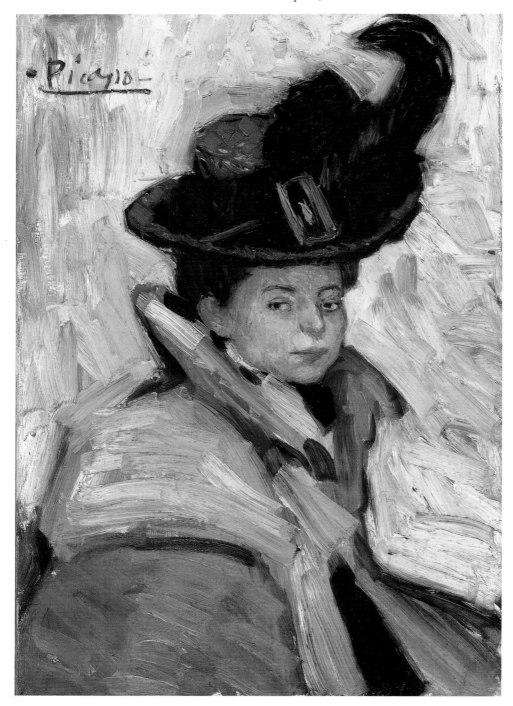

With one of his paintings selected to be in the Spanish pavilion of the 1900 Exposition Universelle in Paris, Picasso took his first trip to that city. Invigorated by the atmosphere there, he remained several months, making the rounds of cabarets and brothels as well as the venues of the Exposition. Paris was to become his home, although he frequently returned to Spain.

 Woman with a Cape relates to the portraits of women Picasso had done when he lived in Barcelona and Madrid, which show the influence of the Spanish painters Velázquez and Goya; it also reveals his high regard for the works of Manet, van Gogh, and Neo-Impressionists such as Seurat, Paul Signac, and Henri Gross, which he saw during his first trip to Paris. Here he applied the paint thickly, and the brushstrokes and color generate the forms and bring the canvas to life.

La Vie 1903

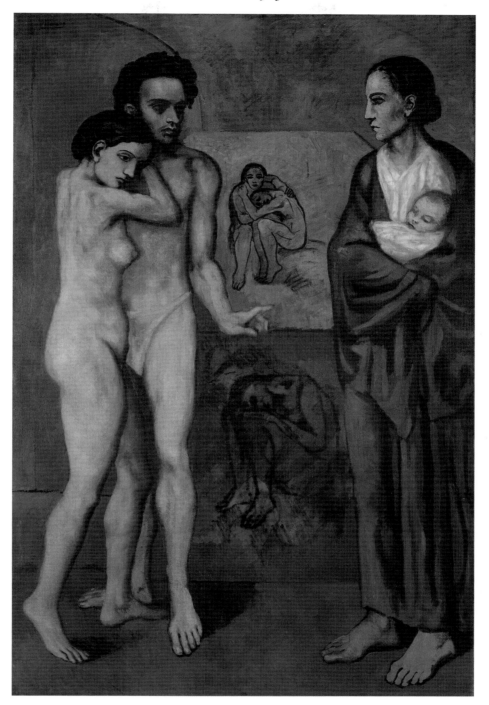

La Vie, or *Life,* is among the largest and most complex paintings of Picasso's Blue Period. During this time he concentrated primarily on the human figure, rendered in an almost monochromatic blue, and often dealt with issues of misery and destitution. *La Vie* was painted in Barcelona, where the artist spent some of his early years before moving permanently to France. Set in an artist's studio, the composition contains two pairs of figures separated by two canvases—just in the beginning stages of development—stacked one on top of the other. The male figure was originally a self-portrait, but Picasso later changed the face to resemble that of Carlos Casagemas, a friend who had committed suicide after being rejected by a lover. Extensive study and X-radiography have revealed another composition under the final one, but the meaning of this complex meditation on love and life has yet to be determined.

The Harem 1906

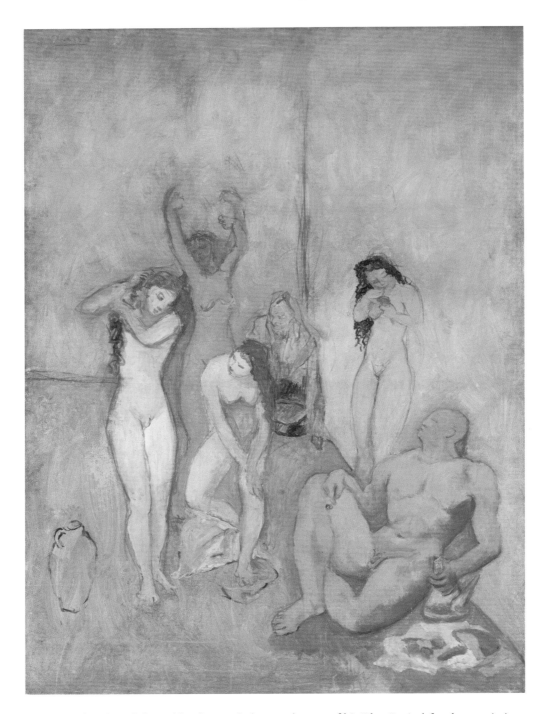

In 1904 Picasso abandoned the cold colors and gloomy themes of his Blue Period for the poetic images of the Rose Period. In the summer of 1906 he visited Spain with his current lover, Fernande Olivier. They spent most of their time in Gósol, a remote Catalan village in the Pyrenees Mountains. Captivated by Fernande's beauty, Picasso repeatedly sketched her bathing, combing her hair, and looking at herself in a mirror. This painting combines various views of Fernande at her toilette, but it places her in the context of 19th-century bathing and harem scenes. The poses recall the figures in Ingres's famous painting *The Turkish Bath,* but Picasso's odalisque in the foreground is male, enjoying a meal of sausage, bread, and wine. The bottle he grasps suggestively is a *porrón,* a Spanish drinking vessel. The skewed perspective adds to the otherworldly atmosphere of this personal rose-colored harem.

The Houses of Parliament from Westminster Bridge 1906

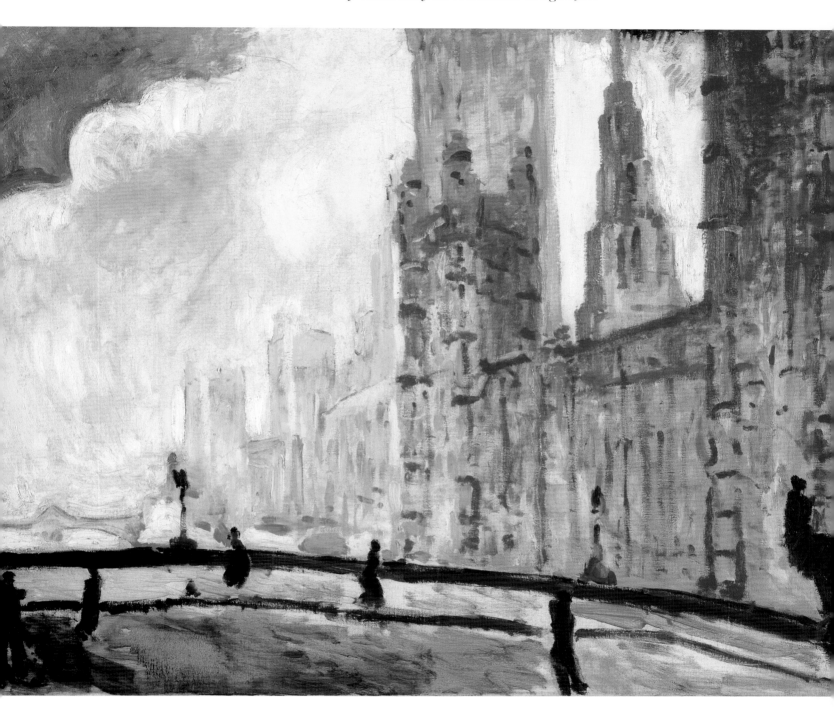

On a trip financed by his dealer to the gray, foggy London of Galsworthy and Conan Doyle, Derain packed his paint box with Mediterranean color. Not the color of Impressionism, discovered in the motif, but the Fauve color of Matisse, straight out of the tube, with which he painted the elements of the painting almost monochromatically, assigning to each its own brilliant hue. Only the looming monumentality of the forms foreshadows the brooding solemnity of his later work in somber colors.

Though not really a theorist, in an unpublished treatise on painting Derain sought to formulate for art a meaningful relation to existence. Through line and form, imagery is made to represent timeless issues and ideas; color he deemed incidental. But his gift for color was never lost; it is magnificently evident in his masterpiece of woodcut illustration, a 1943 edition of Rabelais's *Pantagruel*.

Fan, Salt Box, Melon 1909

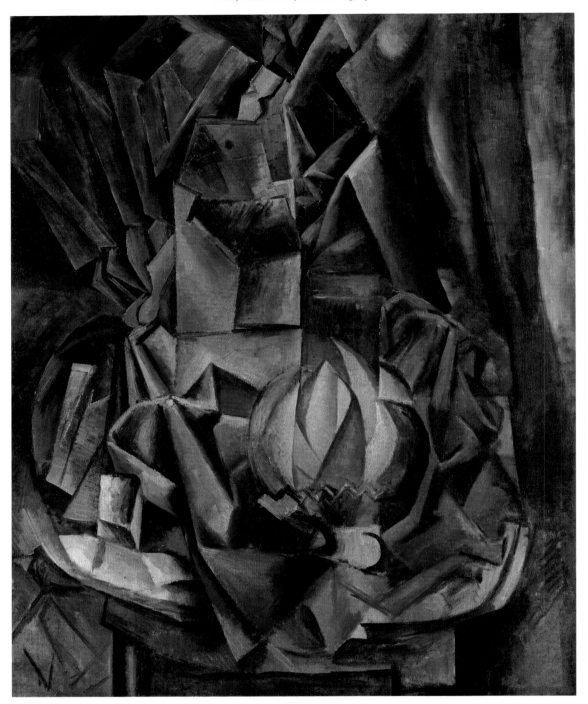

In the fall of 1909, after a summer in Spain, Picasso painted two or three still lifes with a dark green fan on a round table. In this painting the fan is open in the upper left, becoming a series of faceted, geometric planes. A sugar cube, rumpled tablecloth, melon slices in a crystal bowl, and a salt box also rest on the table. Positioned parallel to the picture's surface, these objects are united by a uniform pattern of lights and darks; in fact, pleated fan-like forms dominate the composition. The back of the table is tilted upward, echoing the flat plane of the surface of the picture. Selecting a group of neutral objects so he could concentrate on analyzing form and compressing space in this masterpiece of early Cubist painting, Picasso achieved his revolutionary goal of depicting three-dimensional forms without violating the integrity of the two-dimensional plane.

Bottle, Glass, Fork 1911–12

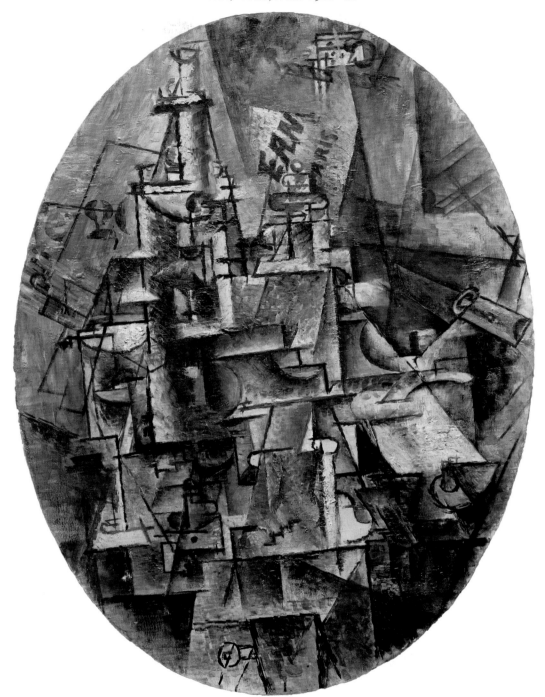

From 1908 to 1912, in a style known as Analytic Cubism, Picasso fragmented objects into increasingly smaller geometric shapes. By 1911 his compositions had come daringly close to total abstraction. The objects in this painting are difficult to discern but include, left to right, a wine glass, corked bottle, folded newspaper, fork, and knife (pointed obliquely toward the center) on a table. At the bottom of this elliptical composition, the knob of a drawer protrudes from the table. Never an advocate of complete abstraction, Picasso included fragmentary words and numbers that connected his subjects to the realities of daily life. The "fe 20" in the upper left may refer to the name or address of a favorite café; the "EAN" above "[P]ARIS" in the upper right probably alludes to the radical Parisian newspaper *L'Intransigeant*. Combined with the wine glasses and newspapers, the fragmented words suggest associations with the artist's life.

Amphora, Fugue in Two Colors II 1910–11

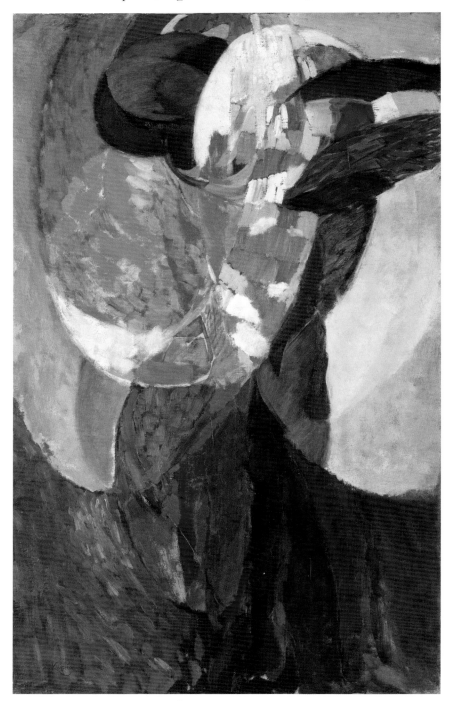

One of the most original innovators of abstraction, Kupka found in music an example of perfect order and formal consistency. He was also inspired by Theosophy, a philosophical mysticism based on the divine origin of all existence. Interest in mystic and spiritual questions was widespread among the intelligentsia in the early 20th century, but Kupka was a man of action as well as an artist; he fought in the Czech resistance in the First World War and was active in politics.

In 1908 Kupka began a series of studies of his stepdaughter playing with a ball in which through the suggestion of motion—after Étienne-Jules Marey's sequential photographs of figures in motion on a single plate—he sought to add the dimension of time, making his work philosophically complete and spiritually relevant. While the metaphysics that generated the work may seem remote after a century, the glowing, swirling image remains compelling.

Forest 1916

Arp called the infinitely variable biomorphic shapes he used "moving ovals." Made of painted wood cut into curving forms, Forest was probably inspired by the twigs, roots, and pebbles of the beach at Ascona, a Swiss town at the top of Lake Maggiore. Ascona was an important meeting place for members of the Dada group, to which Arp belonged from its beginnings in Zurich in 1916. Switzerland attracted many intellectuals from other countries because it was neutral during World War I. Deeply critical of both the social values that led to the war and its resulting carnage, Dada artists and writers created highly unconventional art forms that established important precedents for the activities of the Surrealists a few years later. While the Dada movement had devotees in Paris, New York, Berlin, and Barcelona, its members shared an attitude more than a style: revolution. "Dada" is the French nonsense word meaning "hobbyhorse."

Male Torso 1917

Brancusi's background in rural Romania may have provided him with an earthy persona, but he quickly became one of Europe's most sophisticated artists and one of the 20th century's great innovators. Having walked from Romania to Paris, according to his own account, he washed dishes at a Paris restaurant, studied at the Académie des Beaux-Arts, worked briefly with Rodin, and quickly became quite famous for the radical simplicity of his forms, hitherto unknown in Western sculpture.

The impulse to summarize and simplify appeared early, when Brancusi had begun to use partial figures that he soon began to reduce to symbolic essences. Although the torso is emphatically male, even phallic, there is something feminine as well about the way the light caresses its subtly articulated surface, which swells slightly here and there with minimal departures from geometric form that give the work an androgynous humanity.

Portrait of a Woman c. 1917–18

Modigliani skillfully assimilated stylistic tendencies of his Italian forebears, such as Parmigianino and Botticelli, with a diverse range of more modern influences common among the Parisian avant-garde, including African art, Cambodian art, ancient and Egyptian art, medieval sculpture, and Jewish mysticism, among others. He also cultivated a legendary comportment of the quintessential bohemian artist, with his charm, good looks, and cosmopolitan elegance. Picasso considered Modigliani the "only . . . man in Paris who knows how to dress." His works were mannered as well, and this portrait of an unknown woman displays his subtle use of color, striking linearity, and elegantly elongated forms. Painted two years before his death, it dates from a period when Modigliani frequented the cafés of Paris, sketchbook in hand, chronicling urban settings and individuals in more than 600 portrait drawings and paintings. Jacob Epstein recalled that "all bohemian Paris knew him. His geniality and esprit were proverbial."

The Fight between a Tiger and a Buffalo 1908

This painting is the final one in a series of jungle scenes Rousseau painted between 1904 and 1910. While he never ventured outside France, he read popular travel literature and frequently visited the Jardin des Plantes, the botanical garden in Paris. Like many of his works, this composition is based on a reproduction from a magazine or book. Here Rousseau reconfigured the original (an etching after a painting by Charles Verlat), setting the animals in an implausible tangle of giant exotic plants and subordinating each shape and color to the overall rhythm of the design. The body of the buffalo and the bunches of bananas (growing upside-down) have a similar shape; the tiger leaps at the same angle as the leaves above, and its stripes echo the long, thin leaves in the foreground.

Entirely self-taught, Rousseau is sometimes credited as the greatest naïve artist. Among the avant-garde, painters Picasso, Delaunay, Vlaminck, and Kandinsky, and writers Alfred Jarry, Max Jacob, and Guillaume Apollinaire admired his work.

Still Life with Rayfish c. 1923

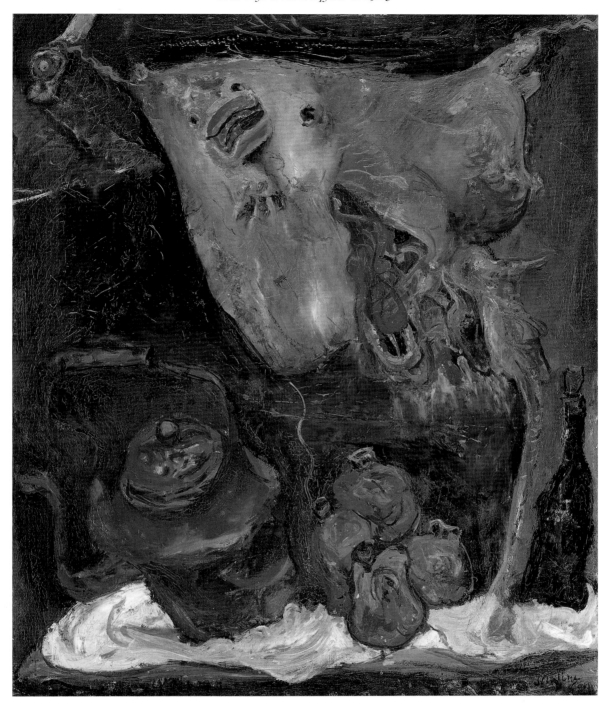

The venerable rayfish in this painting made its first appearance in 1728, in a painting by Chardin, who presented it to the Académie. Soutine, whose academy was the Louvre, created an homage to Chardin's work in the process of completely reinventing it for himself. (He performed the same alchemy on Rembrandt's *Flayed Ox,* famously splashing a carcass with blood to keep the colors fresh.)

Soutine came from the shtetl of Smilovitchi, near Minsk, but where his style came from no one can say. Unlike Chagall, he addresses no Jewish themes, and there is no evidence that his ethnic heritage meant much to him before the Nazis forced him to wear the star. Uninterested in Cubism or Surrealism, his extraordinary individuality appears to have been his own invention. Nothing he could have seen at the Louvre would have suggested his expressive intensity, not to be equaled until the advent of the Abstract Expressionists.

The Coffee Mill 1916

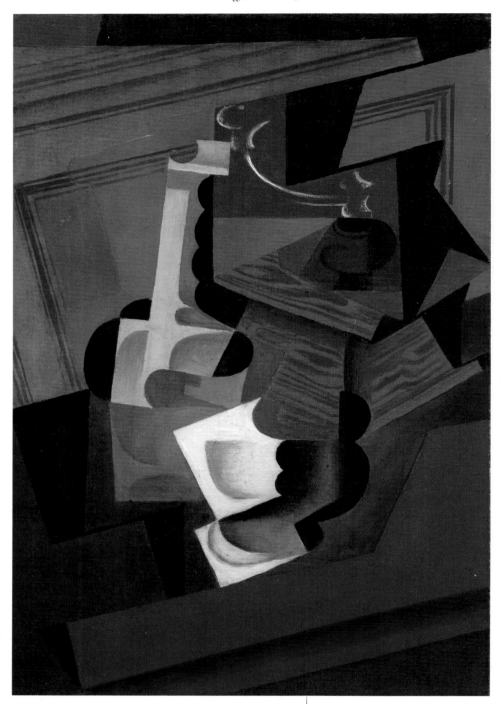

Moving from his native Madrid to the Montmartre district of Paris in 1906, Gris settled in the Bateau-Lavoir, the building where Picasso and many other poor immigrant artists had their studios. Gris began painting in a Cubist style around 1910, developing a highly refined approach that emphasized sharply defined forms and austere geometric structure. After 1915, his compositions became more complex and his color richer, as seen in the lavender, sky blues, and olive greens of this painting. The objects depicted—coffee mill with white handle, bottle, and wine glass on a table covered with a green cloth—are almost indecipherable, showing his concern for structural unity. To provide greater textural variety, he rendered the base of the coffee mill in a simulated wood-grain pattern that relates this painted image to the real object.

The paintings Gris produced during the period 1913–18 are considered among the best of his career.

Harlequin with Violin 1918

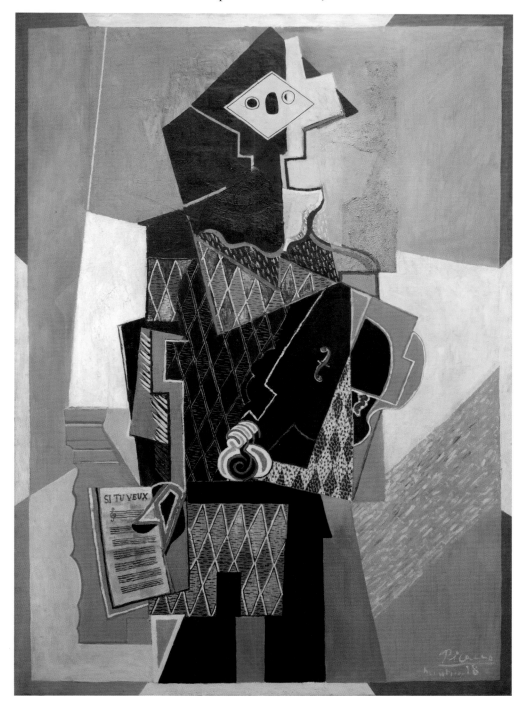

Picasso painted *Harlequin with Violin* in the style known as Synthetic Cubism, in which lively colors and large geometric shapes were used to depict recognizable subjects. Here, the violin and sheet music provide hints of the picture's meaning. The diamond-pattern costume and dark, triangular hat identify the musician as Harlequin, a character from the popular theater known as the Commedia dell'arte, which originated in Italy. For many years Picasso depicted himself as this jokester, yet the musician here also wears the mask and white hat of the melancholy Pierrot, another character in the Commedia. Perhaps the most revealing clue to the painting's meaning is written at the top of the sheet of music—the words "Si Tu Veux"—the beginning phrase of a popular song (If you like . . . make me happy). It may have been intended as a loving joke to the Russian ballet dancer Olga Koklova, whom Picasso married in 1918.

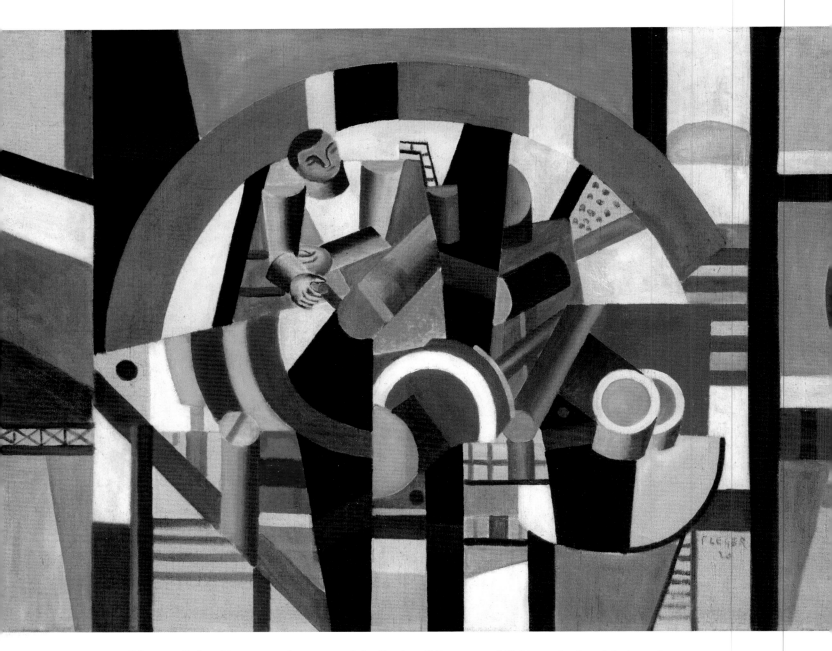

Léger studied architecture and was part of the Section d'Or group of Cubists, who based their works on patterns from nature. World War I interrupted his career just when he had reached complete abstraction. Recalling his experiences, he wrote: "During those four years, I was abruptly thrust into a reality which was both blinding and new. . . . My new companions in the Engineer Corps were miners, navvies, workers in metal and wood. Among them I discovered the French people." After the war, he dedicated his life to creating art for every class of society and proclaimed his faith in progress.

This painting celebrates aviators. The lucid structure, bold color contrasts, and machine-like forms outlined in black (he was called a "tubist" for a time) are typical of his style. Fragments represent entire objects. Here the arching curves created with violet, white, black, yellow, and green shapes suggest the energetic movement of a whirling propeller.

Still Life with Biscuits 1924

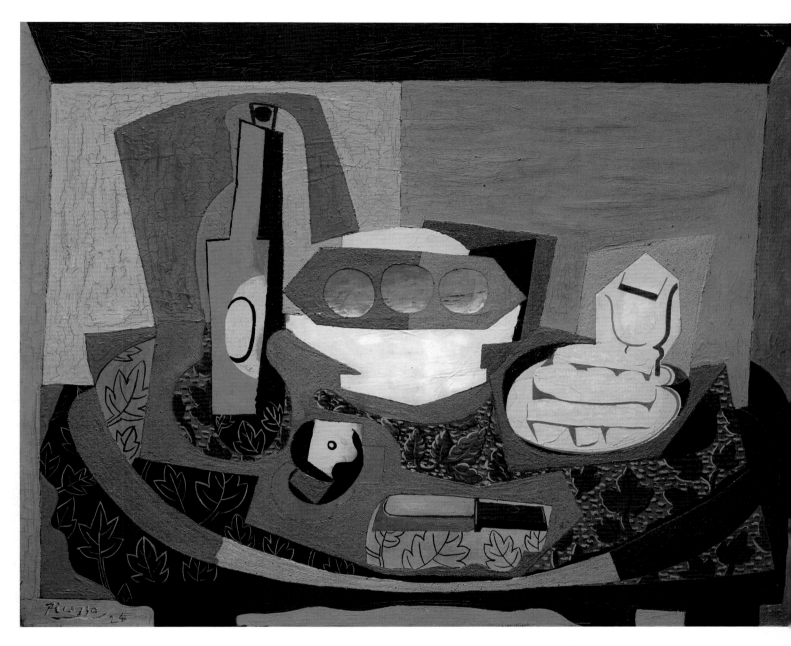

Painted at Juan-les-Pins on the French Riviera, this composition belongs to a series of large Synthetic Cubist still lifes Picasso created during the 1920s. Its cheerful, lively colors and playful forms reflect a relatively tranquil time in the artist's personal life—between the birth of his first son, Paolo (1921), and the deterioration of his marriage to Olga Koklova. This picture, like others from the period, expresses the simple pleasures of domestic life. On a table partly covered by a leaf-patterned cloth, are a bottle, three pieces of fruit in a white bowl, a sliced apple (painted black and blue), a knife, and a glass behind a plate of biscuits. In this highly imaginative pictorial space, certain objects function as both positive and negative shapes. The sand Picasso added to certain color areas creates rough surfaces that contrast with smoother ones where brushstrokes are nearly invisible, adding to the spatial complexity.

Festival of Flowers, Nice 1923

Matisse often worked in his hotel rooms at Nice, and windows are everywhere in these paintings. Here we have stepped through the window with the painter's daughter Marguerite and model Henriette, who prepare to toss their flowers on the parade. The sun shines, the band plays, the flags wave, the last world war is five years in the past and the next 17 in the future; all over Europe artists have returned to their roots, abjuring prewar modernism, and Matisse paints the scene before him almost as straightforwardly as Pissarro. But these dots of color are not an impressionist summation of the world in light, but signs abstracted from objects—a flower, a hat, a flag—from which Matisse builds his personal paradise of color. Twenty years later this simultaneity of line and color would become the foundation of his last, great style, in the decoration of the chapel at Vence and other works based on cutout shapes.

Guitar and Bottle of Marc on a Table 1930

This classic work from Braque's series of "guéridon" paintings (after the round pedestal tables that recur in the works) displays his innovative use of materials, textures, complex patterning, and colors applied to traditional still life. Co-inventor of Cubism with Picasso, Braque depicted volume by deconstructing and reconstructing objects in paint. The guitar, with its hollow form and curvilinear as well as angular shapes, was a favorite motif. A musician, Braque represented the guitar so often that fellow artist Gris is said to have remarked that Braque had found a new Madonna in the guitar. The other objects on the table are also arranged with a precision that scholars have attributed to the influence of Chardin and other classical French artists. The sand mixed with the oil paint creates a rough texture, and the imitation of patterned wallpaper and wood grain in the background bespeaks Braque's original training as a decorator.

Surrealism was not a monolithic movement. Its proponents developed their theories independently, and Magritte held sway in Brussels. He scorned Freud's concepts and the exploration of the subconscious—the stock in trade of Surrealist artists in Paris—and admired the work of the Italian metaphysical painter Giorgio de Chirico. A meticulous craftsman, Magritte used conventional painting techniques to create scenes with ordinary objects arranged in illogical juxtaposition—comparable in spirit to the celebrated definition of beauty by the French poet Isidore Ducasse: "the chance meeting on a dissection table of a sewing machine and an umbrella." The Pop and Postmodern artists of the late 20th century, who present familiar images in new contexts to give them new meaning, are perhaps Magritte's heirs.

 The Secret Life uses the laws of perspective to subvert the traditional conception of a painting as an imitation of reality. Such images are designed to upset our complacent self-assurance in the logic of a predictable world.

The Dream 1931

Surrealist artists and writers believed that reality could be understood only through knowledge of the subconscious. Dalí, a leading member of the movement, produced many paintings inspired by the theories of Sigmund Freud and the new science of psychoanalysis. In this powerful painting, the central figure—with sealed, bulging eyelids and ants clustered over its mouth—suggests the sensory confusion and bizarre drama of a dream. The golden key or scepter held by the man sitting on the pedestal probably symbolizes access to the subconscious. The man himself—with a bleeding face and amputated left foot—calls to mind the lame Oedipus who blinded himself after unwittingly killing his father and marrying his mother. Freud interpreted this classical myth as symbolic of a child's conflicting feelings toward its parents.

Dalí considered this painting particularly significant and insisted it represent him at the first international Surrealist exhibition, organized in London in 1936.

Nocturne 1935

On the eve of the Spanish civil war, Miró painted a series of images showing monstrous figures screaming or running through bizarre landscapes. In this painting, an early work in the series, he heightened the intensity of the stark, acerbic colors by applying the oil paint on copper instead of canvas. Painting on copper is a traditional technique that requires meticulous, small strokes and absolute control. The paint dries very slowly to an enamel-like finish, allowing the artist to manipulate tiny areas. While the eerie landscape *Nocturne* may have come from a nightmare, it was very carefully executed.

Miró visited Paris frequently, but Catalonia remained his home. He never officially joined the Surrealists, although he did share their interest in the subconscious. Stubbornly independent, he never aligned himself with any movement. Experimenting with different techniques in many media throughout a long career, Miró gained international acclaim as a pre-eminent figure in the history of abstraction.

Bull Skull, Fruit, Pitcher 1939

Picasso frequently used the head of a bull as a symbol of brutality and darkness during the 1930s. In January 1939 the world was at war, his beloved Barcelona fell to Franco's army, his mother died, and he suffered painful attacks of sciatica. Here, Picasso expressed his despair by covering the bull skull with decaying yellow flesh. Artists have traditionally used human skulls as memento mori, or reminders of the brevity of life and the inevitability of death. The bull skull, which screams in agony like the wounded horse in *Guernica* (Picasso's monumental painting of the bombing of the town of Guernica during Spain's civil war), evokes associations with the specifically Spanish theme of the bullfight. The composition is dominated by painfully angular forms and pointed shadows that meet at the center to create an "X." Yet amid the horror and the anguish, the flowering tree suggests hope for rebirth and regeneration.

Head of Christ c. 1937

Like the stained glass he learned as an apprentice, Rouault's paintings might be the windows of a vast cathedral dedicated to the nobility of misery. Rouault's prostitutes and clowns are religious figures whose suffering, linking them to Christ, atones for the evil of the world. A disciple of the Symbolist Gustave Moreau, Rouault absorbed Moreau's mythical subjects and tenebrous style, but Moreau's mysticism was the decisive influence, especially the idea that true reality is not material, but can only be apprehended by the spirit.

Despite his religiosity, Rouault's work is not without humor; there is mordant indignation in his series on judges and courts. But at its core his work addresses a profound duality: the inner sadness of the clown, the god who suffers for humanity, the beauty latent in ugliness. He once declared an ambition to paint "a Christ so moving that those who see it will be converted."

Interior with an Etruscan Vase 1940

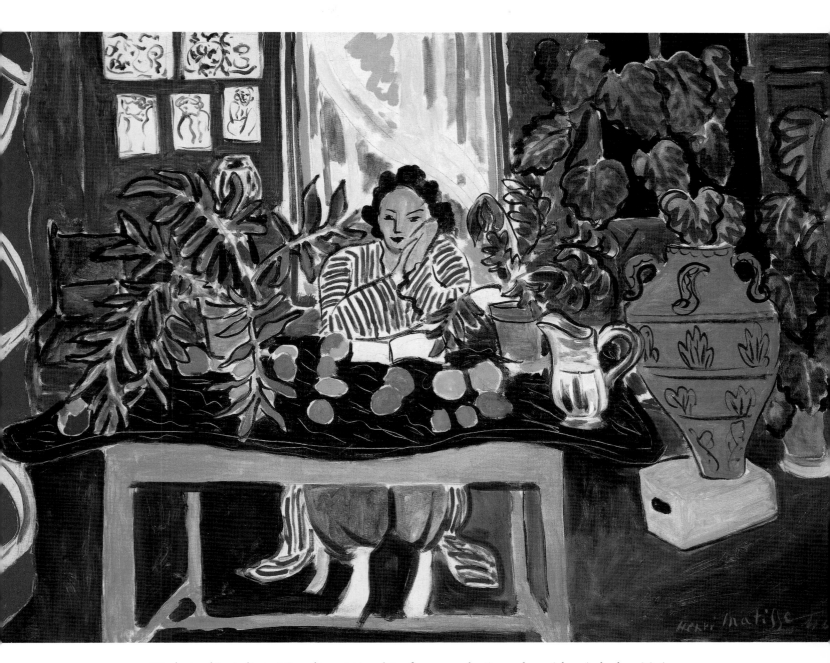

Displaying his studio in Nice, this painting dates from a productive and crucial period when Matisse, once described as the "eternal optimist" (and the ultimate foil to Picasso), was attempting to create an oasis amid the onslaught of World War II. The setting, resplendent with tropical plants, fruits, and vases, allowed him to include his own paintings (a favorite motif) and thus add color, pattern, mystery, and variation to the scene. Tacked on the wall at the back are five drawings; directly behind the model hangs the cartoon for his tapestry *Nymphs in a Forest*. While the cartoon provides a bright area as would a window, the actual window at right is covered, perhaps foreshadowing the blackouts during the Blitz. The interplay of colors and the interstices of blank canvas and arabesque line create a lively, syncopated pattern and show Matisse's resolve to create a harmonious whole.

Le Déjeuner sur l'Herbre 1944

A founding member of the Surrealist group in Paris, Ernst had established a Dada group earlier in Cologne. He fled to America in 1941 to escape Nazi persecution.

This painting parodies Manet's *Le Déjeuner sur l'Herbe* (Luncheon on the Grass) of 1863, which historians associate with the birth of modern art. Inverting Manet's image of a nude woman sitting with two clothed men in a forest, Ernst substituted a fish for the woman and eliminated the other figures. He transformed Manet's bucolic landscape into a thorny realm and replaced the feast with an empty wine bottle. Fish—this one has razor-sharp teeth and startling blue eyes—were to appear regularly in Surrealist art as metaphors for delving into the mysterious, watery depths of the subconscious mind. The nonsense word *herbre* (not *herbe* as in Manet's painting) is close in pronunciation to the French obscenity *merde*.

The terrible events of the 20th century deepened Rouault's melancholy. Of those who found his focus on misery narrow-minded, he wrote: "They have never understood the depth of my ideas on this humanity I seem to denigrate. Unlike me, they have never heard, with the same intensity, in war or peace, the death-rattle of the beast with its throat cut, the gaping mouth from which no sound comes, as in a terrible dream."

Yet he found a measure of consolation late in his career, in serene landscapes whose format of small figures before a background of glowing color suggests a reconciliation of mankind and the world. The intensity of the color depends on contrast with the heavy black around them, just as Rouault's faith drew strength from his despair. Whatever their titles, the bare hills and smoldering skies of these works are those of the Bible, the timeless world that, for Rouault, represented mankind's spiritual home.

North Light

Modernism in Northern Europe and the British Isles

In 1909, when Matisse established an informal school in the empty convent where he lived in Paris with his family, most of his students were northern European, from Scandinavia, Germany, and Russia, drawn to the Parisian avant-garde like moths to a candle. The realization that art could transcend literal depiction, with color explored for its own sake and form invented instead of passively accepted, exerted a tremendous centripetal force.

Paris gave the artists of the north new vocabularies with which to address subjects proper to their chilly homelands. An earnest engagement with social problems characterizes the work of artists from Holland and Belgium, where rapid industrialization had ravaged the countryside and convulsed society: Breitner used the methods of French Impressionism in a forensic examination of his almost monochrome city of Amsterdam, Meunier gave the industrial underclass heroic stature, and Minne invested psychological alienation from the prevalent materialism with a wistful monumentality. Mondrian devoted himself to formal inventions that became as influential as the work of Picasso or Matisse.

In Germany and Scandinavia the human figure became the focus of striking expressive strategies, from Corinth's feverishly expressive impressionistic painting to the bitter incisiveness of Dix. In the British Isles, where the portraits of Gilman and Orpen responded to Post-Impressionist trends, and Nicholson and Moore created some of the century's most enduring works of abstraction, the message of modernism traveled north, awakening sensibilities like those in W. H. Auden's poem "Night Mail" to the strongest current in modern European art.

> Thousands are still asleep
> Dreaming of terrifying monsters,
> Or of friendly tea beside the band at Cranston's or Crawford's:
> Asleep in working Glasgow, asleep in well-set Edinburgh,
> Asleep in granite Aberdeen,
> They continue their dreams,
> And shall wake soon and long for letters,
> And none will hear the postman's knock
> Without a quickening of the heart,
> For who can bear to feel himself forgotten?

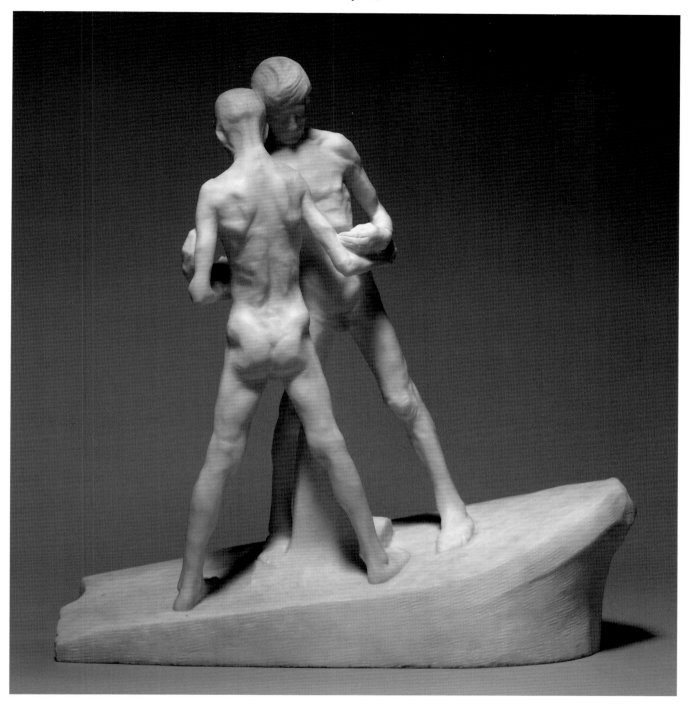

One of several Belgian artists who sought refuge from the materialism of society first in an abandoned monastery, then in the countryside, Minne was repelled by the social degradation wrought by the Industrial Revolution in Europe. Sustained by the friendship of the Symbolist poet Maurice Maeterlinck and the admiration of Rodin, he turned to medieval art for inspiration, exalting craftsmanship and spirituality.

A slender adolescent figure, the subject of many of Minne's early sculptures, appears here twice in an allegory of two brothers balancing on a small boat, a proposal for a memorial to the socialist leader Jean Volders. When it was refused, Minne destroyed the full-size model, but this smaller version survives.

In 1899 Minne moved to the tiny village of Sint-Martens-Latem, a refuge for many Belgian artists from Ghent's cycle of unrest and repression. Except for exile in Wales during the First World War, he never left it.

Construction Site in Amsterdam c. 1902

Sketching partners in the early 1880s, Breitner and van Gogh shared a common artistic ideal at the time: intense, forceful presentation of Naturalist subjects. They attempted to record the world around them with scientific precision. Breitner spent part of 1884 painting street scenes in Paris, however, and came under the sway of the Impressionists. After his return to Holland, he quickly established himself as the leader of the so-called Amsterdam Impressionists, a group of Hague School artists who chose urban subjects for their tonal paintings.

Amsterdam was a city in transition when Breitner lived there during the 1890s, and its various construction sites were an important source of inspiration. He took many photographs, using one of the new portable box cameras that became available in the 1880s. While *Construction Site in Amsterdam* appears to have been painted rapidly on the spot, it was actually constructed carefully in the studio, using photographs and sketches.

The Miners 1800s

In the midst of a successful career as a painter, Meunier found himself in Wallonia, a district of Belgium known as the Black Land, transformed by the Industrial Revolution earlier than the rest of Europe because of its vast coal fields. "I was struck by that tragic and wild beauty," he wrote, "an immense pity seized me."

The grandeur and pathos he found in labor revitalized Meunier's art. Sincerely engaged by social issues and artistically conservative but very well informed, he devoted the rest of his life to applying to the industrial age the visualization of the universal human ideals he recognized in classical sculpture. He continued to paint, but now his industrial landscapes could be seen as backdrops for his sculpted figures. In this work the figures crowd a shallow space with the oppressive constriction of a mine shaft, and the figures are scarcely idealized, reflecting an elemental struggle with the earth.

Field with Young Trees in the Foreground c. 1907

For Mondrian landscape was a laboratory for experiments in structure, as he worked in succession in Symbolist, Neo-Impressionist, and Cubist styles in his journey toward abstraction. "I want to approach truth as closely as possible; I therefore abstract everything until I attain the essence of things."

Field with Young Trees in the Foreground also displays the expressivity that never entirely deserted him, exemplified by its summary evocation of sunset or dawn, and the predilection for strongly centered composition announced by the flower paintings and consummated by the abstractions of the 1920s and 1930s, where the central element becomes a void around which the picture is constructed. The primary colors of the late works derive from an intellectual order rather than visual experience, but here the moody colors are still true to the cloudy North Sea landscape. The cursory treatment of trees and fields, emphasized by the frequent exposure of the beige undercoat, denotes an object of contemplation rather than an illustration of landscape.

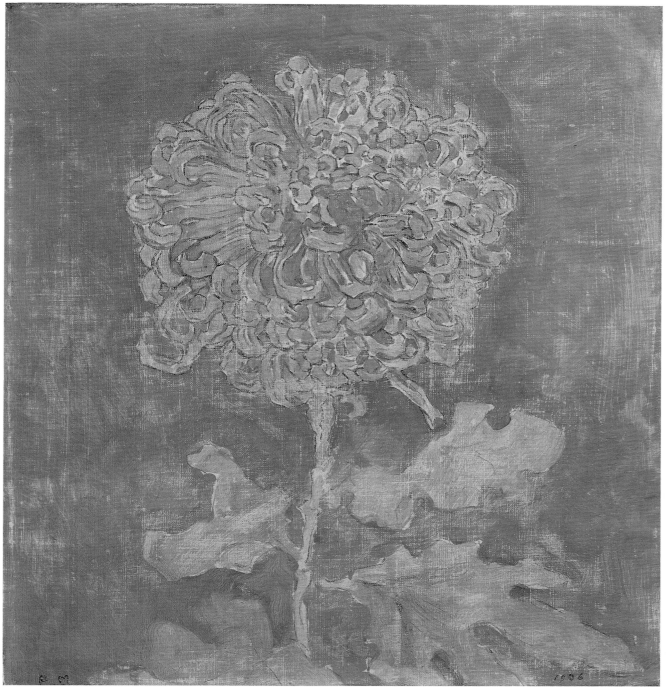

Mondrian always chose residences on upper floors, with north light and low rent—what today we would call lofts. He painted the walls white, the floors black. In Amsterdam he lived on the outskirts of town, within bicycling distance of his favorite landscape subjects. At first he painted them in a conventional, Naturalist manner, but Mondrian was destined to become one of the early inventors of non-objective or abstract art. His Calvinist upbringing found an antidote in the holistic metaphysics of Theosophy, but he treated its themes just as religiously.

He strove from the beginning for profundity: first in nature, as in the iconic single flowers and brooding landscapes, then in proportional systems derived from geometry, and finally in the sublime abstractions of his late career. Alive yet linked with death, the flowers suggest his fascination with dualities as well as the cycle of birth, death, and regeneration that the Theosophists believed was the ruling principle of the universe.

Self-Portrait 1912

In this unusual portrait, Orpen looks at himself in a mirror, holding a rag as if prepared to wipe out the image. Actual ferry tickets, "engaged" seat notices, a personal check, and a page from his diary (referring to a trip to Dublin in June 1912) are glued to the surface. These "intruders" from real life are cleverly arranged to appear to be elements in the painting, pasted on the mirror or stuck into its painted frame. By incorporating actual objects into a medium traditionally devoted to the creation of fictitious illusions Orpen anticipated the collage experiments begun by Braque and Picasso in 1912.

A modernist active in both Ireland and England, Orpen had a very successful and lucrative portrait practice. He came from a family of highly accomplished amateur artists, and while he was a remarkable draftsman, contemporary critics viewed him as no more than a fashionable portrait painter.

Sylvia Gosse c. 1913

The strong color, distinct brushstrokes, and small size of this painting are typical of the work of the British artists who called themselves the Camden Town Group after their shabby North London neighborhood. While they adopted the style and techniques of the Post-Impressionists, their subject matter was different: they were interested in capturing the mundane with honest objectivity. Gilman and Walter Sickert were among the founders of the group, which was active between 1911 and 1914.

Gilman focused on domestic interiors, and this non-idealized, melancholic portrait is one in a series that show his insight and sympathy with his sitters. Sylvia Gosse, daughter of the writer and critic Sir Edward Gosse, was an artist in her own right. While not a member of the group, which did not admit women, she had studied with Sickert and became a family friend. Gosse exhibited regularly and her work is in the collections of a number of British museums.

Self-Portrait with Hat and Coat 1915

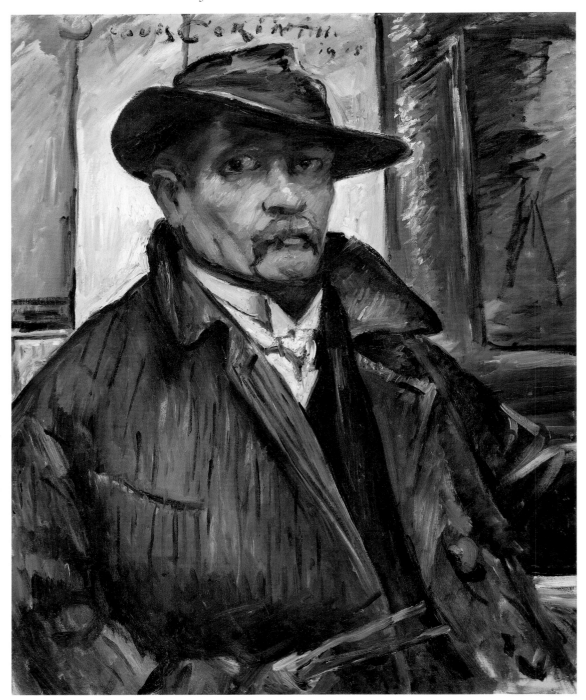

Corinth was trained as a history painter in the tradition of Northern realism, concentrating on the accurate depiction of live models. He became known for spicy, updated scenes from mythology and legend in which grimaces and wrinkles promoted an uneasy contemporaneity, nude 19th-century men and women enacting bizarre mythological tableaux. But when a severe stroke at the age of 53 left him with a weakened body and shaking hand, the deeper reality he had sought in an external approach to legend became interiorized; suddenly any subject sufficed for the most expressive result.

Corinth's self-portraits became one of 20th-century art's great human documents, as he confronted age and debility head on. His style, which modeled form tonally, as light and dark, rather than with impressionist color, nevertheless has the vitality of the impressionist brushstroke; the scale of the brushwork increased as he delved further into himself, until the artist became the art.

Self-Portrait with Hat 1919

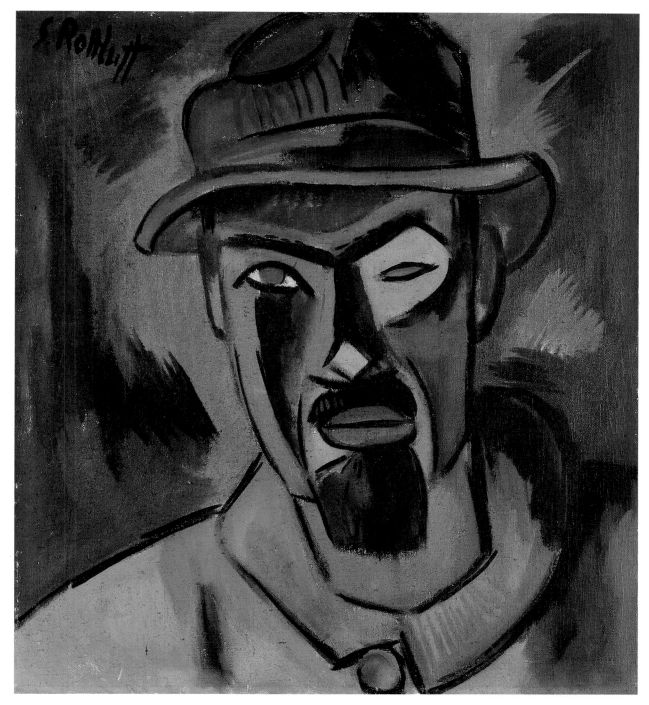

Considered the boldest colorist of the Die Brücke (the Bridge) movement, Schmidt-Rottluff spearheaded the use of flat areas of brilliant color. A founder of this group of German artists in 1905, he chose the name, which symbolized a connection to the future, and encouraged artists such as Emil Nolde to develop an expressionist style. While his landscapes and later figural studies had great impact on the Expressionists in America, in his native Germany his works were classified as "degenerate" during World War II. This particular painting, for instance, was used in Nazi propaganda juxtaposed with photographs of the physically and mentally disabled. The pendant for this self-portrait, probably inspired by van Gogh's self-portraits, is *Emy* (the artist's wife), which likewise displays Schmidt-Rottluff's fascination with bright, acrid colors and monocular vision. Moreover, the self-portrait's bold lines and angular forms reflect his training in woodcut as well as the seminal influence of African sculpture.

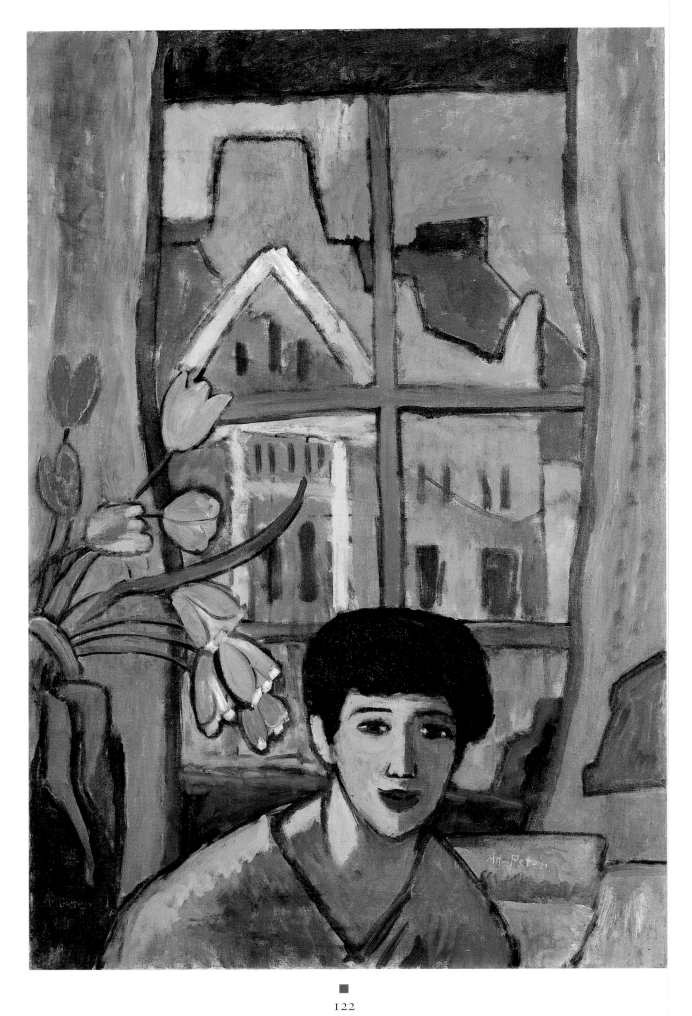

Future (Woman in Stockholm) 1917

Münter studied art in Düsseldorf and at the Phalanxschule in Munich, taking classes with Kandinsky to whom she became engaged. They spent long periods of time in Murnau, where she discovered Bavarian painting on glass, leading to her use of luminous colors and bold forms. Together with Kandinsky and Franz Marc, Münter founded the German Expressionist group Der Blaue Reiter (the Blue Rider) in 1911. Fleeing Germany after the outbreak of World War I, she arrived in Stockholm in 1915, her life with Kandinsky uncertain. *Future* is one in a series Münter painted immediately following the separation that depict solitary women in interior settings. Each image expresses a specific psychological state. She used the same model for some of the works; the figure here appears more contemplative in *Reflecting,* a work completed about a week earlier.

Art historians consider Münter an artist deserving greater recognition, but her achievements have long been overshadowed by her more famous companion, Kandinsky.

Josef May 1926

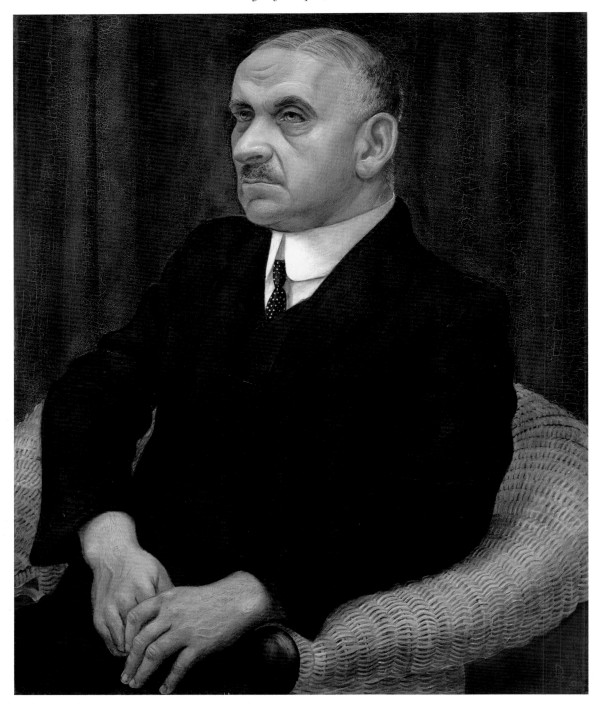

Dix fought heroically in the First World War, which he had expected to liberate society from triviality. When ruin ensued, he grappled with despair through caricatures of suffering and injustice, in a bitter style known as the New Objectivity, characterized by intensely sharp illustrative detail. Once established in the cosmopolitan surroundings of Berlin he turned increasingly to portraiture with techniques inspired by the realists of the Northern Renaissance. A return to relative prosperity brought portrait commissions, which he approached with mordant realism.

Dix's subjects had to forgo flattery. The equal billing accorded inanimate props and the features of the sitters suggest an implacable indifference and lack of idealism.

Josef May, a businessman who had wanted to be an opera singer, got off relatively lightly, but history treated him harshly. He died in exile from the Nazis in Holland. Dix, though excoriated by the regime, survived his second war and continued his career.

■

Singing Man 1928

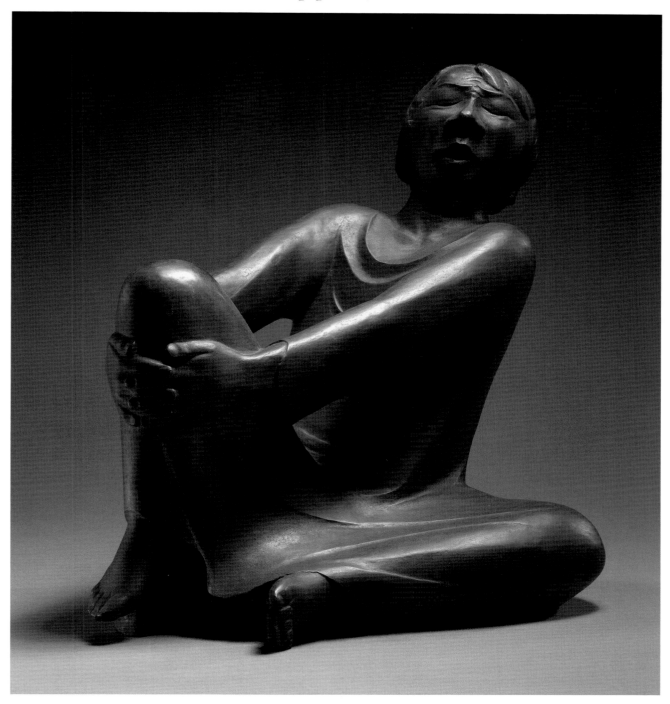

This work entered the collection in 1937, which Barlach called his "terrible year," when the Nazis destroyed many of his public works and expelled him from the Berlin Academy. First suggested in a drawing from 1912 and at last completed in 1928, the work sings of Barlach's stern joy in art and life. This casting has the monumentality of his wood carvings, in which a single block is animated by the angular severity of Gothic art. Even the most serene of his figures has a tense energy.

Barlach drew an aesthetic of primal humanity from the peasants of the Russian steppes, where he traveled in 1906, and found a moral foundation in Christianity. Included in the official Degenerate Art exhibition, a Who's Who of early modernism in Germany, he is celebrated today for his vital reinvention of traditional forms, as well as for principled intransigence and moral seriousness.

■

Composition with Red, Yellow, and Blue 1927

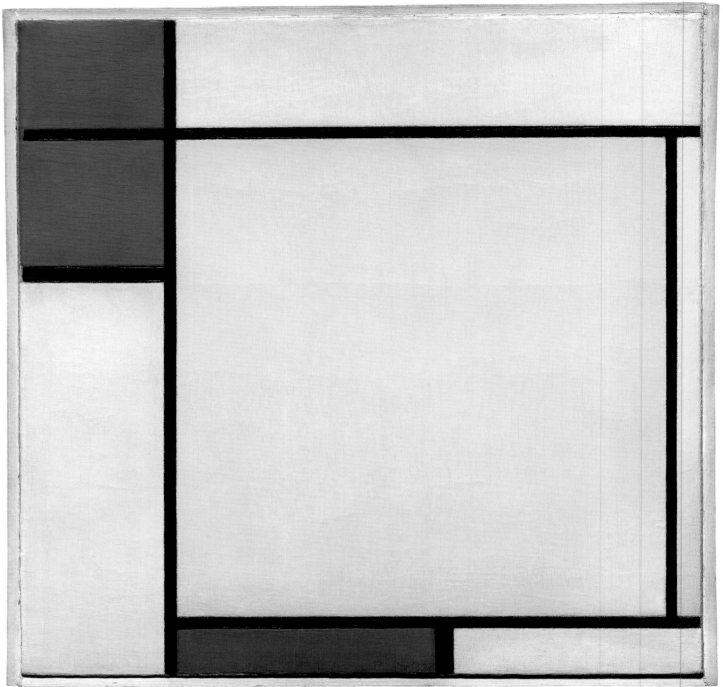

After working for 20 years in Amsterdam and engaged to be married, Mondrian left for Paris, breaking the engagement. If the First World War had not intervened he might never have returned to Holland. Mondrian's last, great style was initiated through involvement with the ideas of the Dutch group De Stijl (The Style), asserting that painting must express a universal cosmic order. Their vertical and horizontal lines, primary colors, and flat shapes are arranged in balanced compositions that deny any illusion of conventional depth.

Having returned to Paris in 1919, Mondrian was driven away again by the approach of war. He established his last studio with north light and white walls in New York, where he continued to assemble his rectangles and lines in canvases indissolubly welded into unique compositions, windows on a universe of pristine order beyond the edges of the canvas. The tactile reality of these magisterial works is hidden in reproduction; the brushwork's patient care gives them a painterly intimacy.

1941 (relief) 1941

One of the pioneers of abstract art in Great Britain, Nicholson merged Cubist principles of design and construction with suggestive shapes inspired by Surrealism. A member of the avant-garde group Unit One during the early 1930s, he settled in St. Ives in Cornwall, where his studio became a gathering place for artists fleeing London at the beginning of World War II.

While displaying the harmony, purity of form, and complex interplay of solids and voids characteristic of the "white reliefs" Nicholson created in London, *1941 (relief)* also demonstrates the influence of Mondrian, whom he had met not long before in Paris. The drawn elements and vertical format indicate a new presentation of space, perhaps a response to living in Cornwall, with its proximity to the sea. The serene shapes suggest Nicholson discovered a refuge in art at a time when Britain was struggling to survive the onslaught of the Nazi blitz.

Three-Way Piece No. 2: Archer 1964

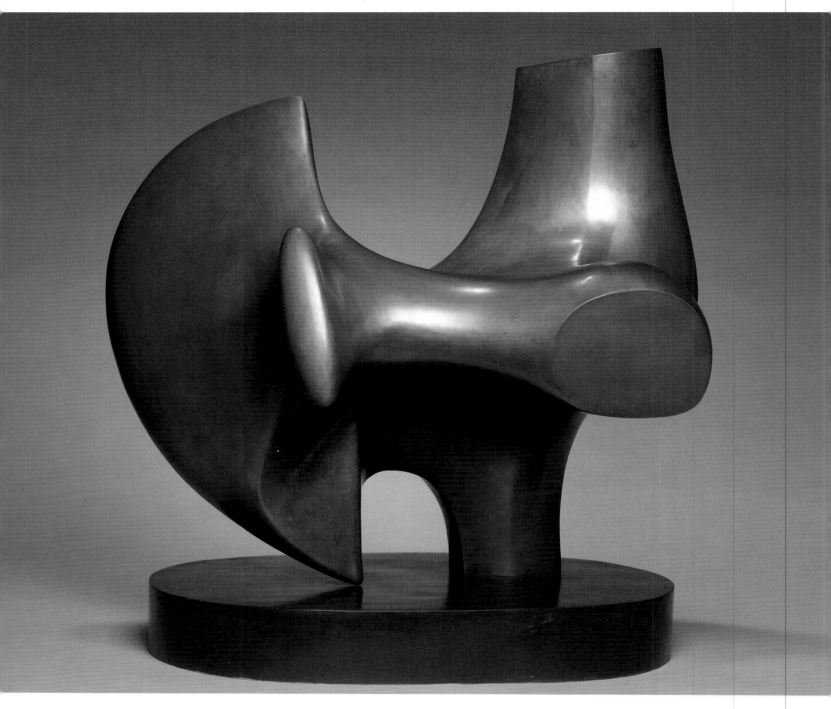

Considered by many to be the 20th century's greatest figurative sculptor, Moore also created remarkable abstract works. *Three-Way Piece No. 2: Archer* does not literally depict an archer, but it does evoke the vigor, strength, and conflict associated with warriors or hunters. The title's three "ways" may refer to the main elements of the work: the large sweeping form has the shape of a taut bow; the taller vertical section suggests a torso leaning backward; and the horizontal section linking the vertical and bow-shaped forms calls to mind a raised arm bent at the elbow.

 At the beginning of his career, Moore embraced non-European sculptural traditions and was sensitive to the qualities inherent in the materials he used. His sculpture and drawings from the 1930s show the influence of Arp and Picasso; later works are based on the human figure or other natural forms.

Edmond François Aman-Jean (French, 1858–1936). *Portrait of a Woman,* c. 1891, oil on fabric, 84.4 x 89.5 cm. Mr. and Mrs. William H. Marlatt Fund 1972.120

Jean Arp (French 1887–1966). *Forest,* 1916, painted wood, 41.3 x 53 cm. Contemporary Collection of The Cleveland Museum of Art 1970.52

Ernst Barlach (German, 1870–1938). *Singing Man,* 1928, bronze, width 55.6 cm. Hinman B. Hurlbut Collection 3204.1937

Albert Besnard (French, 1849–1934). *Madeleine Lerolle and Her Daughter Yvonne,* c. 1879–80, oil on fabric, 165 x 115.5 cm. Gift of Mr. and Mrs. Noah L. Butkin 1977.120

Pierre Bonnard (French, 1867–1947). *Café Terrace,* 1898, oil on board, 33.8 x 49.5 cm. Anonymous Gift 1976.148

Pierre Bonnard. *The Dessert, or After Dinner,* c. 1920, oil on fabric, 76.2 x 80 cm. Gift of the Hanna Fund 1949.18

Pierre Bonnard. *The Road to Nantes,* 1929, oil on fabric, 69.2 x 66.2 cm. Bequest of Leonard C. Hanna Jr. 1958.17

Eugène Boudin (French, 1824–1898). *The Beach at Deauville,* 1864, oil on wood panel, 37.4 x 26 cm. Gift of Mrs. Homer H. Johnson 1946.71

Constantin Brancusi (Romanian, 1876–1957). *Male Torso,* 1917, brass, height 46.7 cm. Hinman B. Hurlbut Collection 3205.1937

Georges Braque (French, 1882–1964). *Guitar and Bottle of Marc on a Table,* 1930, oil and sand on canvas, 130.5 x 75 cm. Leonard C. Hanna Jr. Fund 1975.59

George Hendrik Breitner (Dutch, 1857–1923). *Construction Site in Amsterdam,* c. 1902, oil on fabric, 60.5 x 80.7 cm. Mr. and Mrs. William H. Marlatt Fund 1985.145

Paul Cézanne (French, 1839–1906). *The Brook,* c. 1895–1900, oil on fabric, 59.1 x 81 cm. Bequest of Leonard C. Hanna Jr. 1958.20

Paul Cézanne. *Mount Sainte-Victoire,* c. 1904, oil on fabric, 72.2 x 92.4 cm. Bequest of Leonard C. Hanna Jr. 1958.21

Paul Cézanne. *The Pigeon Tower at Bellevue,* 1889–90, oil on fabric, 65.6 x 81.5 cm. The James W. Corrigan Memorial 1936.19

Lovis Corinth (German, 1858–1925). *Self-Portrait with Hat and Coat,* 1915, oil on canvas, 99.7 x 78.8 cm. Leonard C. Hanna Fund 1979.14

Gustave Courbet (French, 1819–1877). *Laure Borreau,* 1863, oil on canvas, 81 x 61.2 cm. Leonard C. Hanna Jr. Fund 1962.2

Gustave Courbet. *Panoramic View of the Alps, La Dent du Midi,* 1877, oil on fabric, 151.2 x 210.2 cm. John L. Severance Fund and various donors by exchange 1964.420

Salvador Dalí (Spanish 1904–1989). *The Dream,* 1931, oil on canvas, 96 x 96 cm. John L. Severance Fund 2001.34

Edgar Degas (French, 1834–1917). *Dancer Looking at the Sole of Her Right Foot,* 1896–97, bronze, height 45.8 cm. Hinman B. Hurlbut Collection 2028.1947

Edgar Degas. *Frieze of Dancers,* c. 1895, oil on fabric, 70 x 200.5 cm. Gift of the Hanna Fund 1946.83

Edgar Degas. *Stefanina Primicile Carafa, Marchioness of Cicerale and Duchess of Montejasi,* c. 1875, oil on fabric, 49.7 x 39.9 cm. Bequest of Leonard C. Hanna Jr. 1958.28

Maurice Denis (French, 1870–1943). *Eva Meurier in a Green Dress,* 1891, oil on canvas, 55 x 38 cm. Mr. and Mrs. William H. Marlatt Fund 2002.92

André Derain (French, 1880–1954). *The Houses of Parliament from Westminster Bridge,* 1906, oil on canvas, 73.6 x 92 cm. Leonard C. Hanna Jr. Fund 1983.67

Otto Dix (German, 1891–1969). *Josef May,* 1926, oil and other media on board, 84 x 68.8 cm. Purchase from the J. H. Wade Fund 1985.40

Max Ernst (German, 1891–1976). *Le Déjeuner sur l'Herbre,* 1944, oil on canvas, 68 x 150 cm. Leonard C. Hanna Jr. Fund 2002.55

Henri Fantin-Latour (French, 1836–1904). *Madame Lerolle,* 1882, oil on fabric, 108.2 x 78.9 cm. Purchase from the J. H. Wade Fund and the Fanny Tewksbury King Collection by exchange 1969.54

Henri Fantin–Latour. *Marie-Yolande de Fitz-James,* 1867, oil on fabric, 50.2 x 42.2 cm. Gift of Lewis C. Williams 1982.256

Paul Gauguin (French, 1848–1903). *In the Waves,* 1889, oil on fabric, 92.5 x 72.4 cm. Gift of Mr. and Mrs. William Powell Jones 1978.63

Paul Gauguin. *The Large Tree,* 1891, oil on fabric, 74 x 92.8 cm. Gift of Barbara Ginn Griesinger 1975.263

Harold Gilman (British, 1876–1919). *Sylvia Gosse,* c. 1913, oil on canvas, 61 x 51 cm. Mr. and Mrs. William H. Marlatt Fund 1982.125

Vincent van Gogh (Dutch, 1853–1890). *Adeline Ravoux,* 1890, oil on fabric, 50.2 x 50.5 cm. Bequest of Leonard C. Hanna Jr. 1958.31

Vincent van Gogh. *The Large Plane Trees,* 1889, oil on canvas, 73.4 x 91.8 cm. Gift of the Hanna Fund 1947.209

Vincent van Gogh. *The Poplars at Saint-Rémy,* 1889, oil on fabric, 61.6 x 45.7 cm. Bequest of Leonard C. Hanna Jr. 1958.32

Juan Gris (Spanish, 1887–1927). *The Coffee Mill,* 1916, oil on canvas, 55 x 38 cm. Purchase from the J. H. Wade Fund 1980.8

Johan Barthold Jongkind (Dutch, 1819–1891). *The Seine at Bas-Meudon,* 1865, oil on canvas, 34.1 x 48.1 cm. Gift of the family of Constance Mather Bishop 1993.236

Frantisek Kupka (Czech, 1871–1957). *Amorpha, Fugue in Two Colors II,* 1910–11, oil on canvas, 111.7 x 68.6 cm. Contemporary Collection of The Cleveland Museum of Art 1969.51

Fernand Léger (French, 1881–1925). *The Aviator,* 1920, oil on canvas, 65 x 92 cm. Leonard C. Hanna Jr. Fund 1981.16

René Magritte (Belgian 1898–1967). *The Secret Life,* 1928, oil on canvas, 54 x 72.8 cm. Bequest of Lockwood Thompson 1992.298

Édouard Manet (French, 1832–1883). *Berthe Morisot,* c. 1869, oil on fabric, 74 x 60 cm. Bequest of Leonard C. Hanna Jr. 1958.34

Henri Matisse (French, 1869–1954). *Festival of Flowers, Nice,* 1923, oil on canvas, 65.5 x 92.7 cm. Mr. and Mrs. William H. Martlatt Fund 1946.444

Henri Matisse. *Interior with an Etruscan Vase,* 1940, oil on canvas, 73.7 x 108 cm. Gift of the Hanna Fund 1952.153

Constantin Meunier (Belgian, 1831–1905). *The Miners,* 1800s, bronze, height 55.3 cm. In memory of Ralph King; gift of Mrs. Ralph King, Ralph T. Woods, Charles G. King, and Frances King Schafer 1946.349

George Minne (Belgian, 1866–1928). *Solidarity,* 1898, marble, height 68 cm. Andrew W. and Martha Holden Jennings Fund 1968.191

Joan Miró (Spanish, 1893–1983). *Nocturne,* 1935, oil on copper, 42 x 29.2 cm. Mr. and Mrs. William H. Martlatt Fund 1978.61

Amedeo Modigliani (Italian, 1884–1920). *Portrait of a Woman,* c. 1917–18, oil on canvas, 65 x 48.3 cm. Gift of the Hanna Fund 1951.358

Piet Mondrian (Dutch, 1872–1944). *Chrysanthemum,* oil on canvas, 41.5 x 38.5 cm. Signed lower left: PM; lower right: 1906. Probably signed and dated in New York for an exhibition at the Valentin gallery in January 1942. Bequest of Leonard C. Hanna Jr. 1958.38

Piet Mondrian. *Composition with Red, Yellow, and Blue,* 1927, oil on canvas, 49.5 x 49.5 cm. Contemporary Collection of The Cleveland Museum of Art 1967.215

Piet Mondrian. *Field with Young Trees in the Foreground,* c. 1907, oil and paper laid down on board, 65.7 x 72 cm. Gift of Frank Stella 1971.220

Claude Monet (French, 1840–1926). *Gardener's House at Antibes,* 1888, oil on fabric, 66.3 x 93 cm. Gift of Mr. and Mrs. J. H. Wade 1916.1044

Claude Monet. *Low Tide at Pourville, Near Dieppe,* 1882, oil on fabric, 60.5 x 81.8 cm. Gift of Mrs. Henry White Cannon 1947.196

Claude Monet. *The Red Kerchief: Portrait of Madame Monet,* 1868–78, oil on fabric, 99 x 79.8 cm. Bequest of Leonard C. Hanna Jr. 1958.39

Claude Monet. *Spring Flowers,* 1864, oil on fabric, 116.8 x 90.5 cm. Gift of the Hanna Fund 1953.155

Claude Monet. *Water Lilies (Agapanthus),* c. 1915–26, oil on canvas, 201.3 x 425.8 cm. John L. Severance Fund 1960.81

Claude Monet. *Wheat Field,* 1881, oil on fabric, 64.6 x 81 cm. Gift of Mrs. Henry White Cannon 1947.197

Henry Moore (British, 1898–1986). *Three-Way Piece No. 2: Archer,* 1964, bronze, height (with base) 88.3 cm. Anonymous Gift 1970.112

Berthe Morisot (French, 1841–1895). *Reading,* 1873, oil on fabric, 46 x 71.8 cm. Gift of the Hanna Fund 1950.89

Gabriele Münter (German, 1877–1962). *Future (Woman in Stockholm),* 1917, oil on canvas, 97.5 x 63.8 cm. Gift of Mr. and Mrs. Frank E. Taplin Jr. 1992.96

Ben Nicholson (British, 1894–1978). *1941 (relief),* 1941, oil on wood, 62.3 x 43.8 cm. Contemporary Collection of The Cleveland Museum of Art 1965.449

William Orpen (Irish, 1878–1931). *Self-Portrait,* 1912, oil and collage on wood panel, 61 x 49.6 cm. Mr. and Mrs. William H. Marlatt Fund 1988.11

Pablo Picasso (Spanish, 1881–1973). *The Artist's Sister Lola,* c. 1899–1900, oil on canvas, 46.7 x 37.5 cm. Gift of Mr. and Mrs. David S. Ingalls 1966.377

Pablo Picasso. *Bottle, Glass, Fork,* 1911–12, oil on canvas, 72 x 52.7 cm. Leonard C. Hanna Jr. Fund 1972.8

Pablo Picasso. *Bull Skull, Fruit, Pitcher,* 1939, oil on canvas, 65 x 92 cm. Leonard C. Hanna Jr. Fund 1985.57

Pablo Picasso. *Fan, Salt Box, Melon,* 1909, oil on canvas, 81.3 x 64.2 cm. Leonard C. Hanna Jr. Fund 1969.22

Pablo Picasso. *The Harem,* 1906, oil on canvas, 154.3 x 110 cm. Bequest of Leonard C. Hanna Jr. 1958.45

Pablo Picasso. *Harlequin with Violin,* 1918, oil on canvas, 142.2 x 100.3 cm. Leonard C. Hanna Jr. Fund 1975.2

Pablo Picasso. *La Vie,* 1903, oil on canvas, 196.5 x 129.2 cm. Gift of the Hanna Fund 1945.24

Pablo Picasso. *Still Life with Biscuits,* 1924, oil with sand on canvas, 80.8 x 100.4 cm. Leonard C. Hanna Jr. Fund 1978.45

Pablo Picasso. *Woman with a Cape,* 1901, oil on canvas, 73 x 50.2 cm. Bequest of Leonard C. Hanna Jr. 1958.44

Camille Pissarro (French, 1830–1903). *Edge of the Woods Near l'Hermitage, Pontoise,* 1879, oil on fabric, 125 x 163 cm. Gift of the Hanna Fund 1951.356

Camille Pissarro. *The Lock at Pontoise,* 1872, oil on fabric, 53 x 83 cm. Leonard C. Hanna Jr. Fund 1990.7

Pierre Puvis de Chavannes (French, 1824–1898). *Summer,* 1891, oil on fabric, 149.6 x 232.4 cm. Gift of Mr. and Mrs. J. H. Wade 1916.1056

Odilon Redon (French, 1840–1916). *Vase of Flowers,* c. 1905, oil on fabric, 73 x 59 cm. Gift of Roberta Holden Bole 1935.233

Pierre Auguste Renoir (French, 1841–1919). *The Apple Seller,* c. 1890, oil on fabric, 65.8 x 54.5 cm. Bequest of Leonard C. Hanna Jr. 1958.47

Pierre Auguste Renoir. *Romaine Lacaux,* 1864, oil on fabric, 81.3 x 65 cm. Gift of the Hanna Fund 1942.1065

Auguste Rodin (French, 1840–1917). *The Age of Bronze,* 1875–76, bronze, height (with base) 180.8 cm. Gift of Mr. and Mrs. Ralph King 1918.328

Auguste Rodin. *Fallen Caryatid Carrying Her Stone,* 1880–81, bronze, height 43.5 cm. In memory of Ralph King; gift of Mrs. Ralph King, Ralph T. Woods, Charles G. King, and Frances King Schafer 1946.352

Auguste Rodin. *The Fall of the Angels,* c. 1890–1900, marble, height 52.1 cm. Gift of Carrie Moss Halle in memory of Salmon Portland Halle 1960.85

Auguste Rodin. *Heroic Head of Pierre de Wiessant, One of the Burghers of Calais,* 1886, bronze, height 83.5 cm. The Norweb Collection 1920.120

Auguste Rodin. *Jean d'Aire,* 1884, bronze, height 47 cm. Gift of Loïe Fuller 1917.723

Auguste Rodin. *Study of Honoré de Balzac,* 1891–92, bronze, height 47 cm. Bequest of Edgar A. Hahn 1972.277

Auguste Rodin. *The Thinker,* c. 1880, bronze, height 72.3 cm. Gift of Alexander P. Rosenberg 1979.138

Auguste Rodin. *William E. Henley,* 1882, bronze, height 41.6 cm. Bequest of James Parmelee 1940.581

Auguste Rodin and Albert-Ernest Carrier-Belleuse (French, 1824–1887). *Titans, Support for a Vase,* c. 1877, glazed earthenware, height 36.8 cm. Leonard C. Hanna Jr. Fund 1995.71

Medardo Rosso (Italian 1859–1928). *The Jewish Boy,* 1892 or 1893, wax on plaster, height 22.2 cm. Andrew R. and Martha Holden Jennings Fund 1970.33

Georges Rouault (French, 1871–1958). *End of Autumn No. 4,* 1952, oil on canvas, 75 x 105.4 cm. Gift of Mr. and Mrs. Paul H. Sampliner 1964.161

Georges Rouault. *Head of Christ,* c. 1937, oil on canvas, 104.8 x 75 cm. Gift of the Hanna Fund 1950.399

Henri Rousseau (French, 1844–1910). *The Fight between a Tiger and a Buffalo,* 1908, oil on fabric, 170 x 189.5 cm. Gift of the Hanna Fund 1949.166

Karl Schmidt-Rottluff (German, 1884–1976). *Self-Portrait with Hat,* 1919, oil on canvas, 73.3 x 65 cm. Bequest of Dr. William R. Valentiner 1965.440

Giovanni Segantini (Italian, 1858–1899). *Pine Tree,* c. 1897, oil on fabric, 135.2 x 72 cm. Mr. and Mrs. William H. Marlatt Fund 1982.124

Georges Seurat (French, 1859–1901). *Study for "Bathers at Asnières,"* c. 1883–84, oil on wood panel, 15.7 x 24.9 cm. Bequest of Leonard C. Hanna Jr. 1958.51

Chaim Soutine (Lithuanian, 1893–1943). *Still Life with Rayfish,* c. 1923, oil on canvas, 80.5 x 64.5 cm. Gift of the Hanna Fund 1951.357

James [Jacques-Joseph] Tissot (French, 1836–1902). *July: Specimen of a Portrait,* c. 1878, oil on fabric, 87.5 x 61 cm. Bequest of Noah L. Butkin 1980.288

Édouard Vuillard (French, 1868–1940). *Café Wepler,* c. 1908–10, reworked 1912, oil on fabric, 62.2 x 103.2 cm. Gift of the Hanna Fund 1950.90

Édouard Vuillard. *Under the Trees,* 1894, distemper on fabric, 214.2 x 96.3 cm. Gift of the Hanna Fund 1953.212

Introduction

See John L. Tancock, *The Sculpture of Auguste Rodin: The Collection of the Rodin Museum, Philadelphia* (Boston, Philadelphia: David R. Godine, Philadelphia Museum of Art, 1976), 383.

See Kermit Swiler Champa, *Studies in Early Impressionism* (New Haven: Yale University Press, 1973), 83.

See Diane De Grazia, "Poussin's *Holy Family on the Steps* in Context," *Cleveland Studies in the History of Art* 4 (1999), 57 n. 1.

See Cézanne, *Paul Cézanne: Letters,* ed. John Rewald (Oxford: Bruno Cassirer, 1976), 301.

See Hilary Spurling, *Matisse the Master. A Life of Henri Matisse: The Conquest of Color, 1909–1954* (New York: Alfred A. Knopf, 2005), 426.

The Accuracy of Things

See Louise d'Argencourt and Roger Diederen, *European Paintings of the 19th Century* (Cleveland: Cleveland Museum of Art, 1999), 452.

Mortals, I Am Beautiful

See Carola Giedion-Welcker, *Constantin Brancusi,* trans. Maria Jolas and Anne Leroy (New York: George Braziller, 1959), 13.

Parallel Harmonies

See Cézanne, *Paul Cézanne: Letters,* ed. John Rewald (Oxford: Bruno Cassirer, 1976), 261.

Surprise Me

Francis Steegmuller, *Cocteau: A Biography* (Boston, Toronto: Little, Brown and Company, 1970), 82.

Catalogue Pages

Aman-Jean, *Portrait of a Woman*
See "Les Paradis artificiels," in *Baudelaire, Prose and Poetry,* trans. Arthur Symons (New York, 1926), 235.

Besnard, *Madeleine Lerolle*
See Louise d'Argencourt and Roger Diederen, *European Paintings of the 19th Century* (Cleveland: Cleveland Museum of Art, 1999), 446.

Boudin, *Beach at Deauville*
See Louise d'Argencourt and Roger Diederen, *European Paintings of the 19th Century* (Cleveland: Cleveland Museum of Art, 1999), 64.

Cézanne, *Pigeon Tower*
See Cézanne, *Paul Cézanne: Letters,* ed. John Rewald (Oxford: Bruno Cassirer, 1976), 301.

Courbet, *Laure Borreau*
See Louise d'Argencourt and Roger Diederen, *European Paintings of the 19th Century* (Cleveland: Cleveland Museum of Art, 1999), 160 and 161.

Degas, *Dancer Looking at the Sole of Her Right Foot*
See Degas, *Huit Sonnets d'Edgar Degas* (Paris, New York: La Jeune Parque, George Wittenborn, 1946), 34.

Denis, *Eva Meurier*
See *Columbia Encyclopedia,* 6th ed., 28 December 2005, http://www.bartleby.com/65/de/Denis-Ma.html.

Fantin-Latour, *Marie Yolande de Fitz-James*
See Louise d'Argencourt and Roger Diederen, *European Paintings of the 19th Century* (Cleveland: Cleveland Museum of Art, 1999), 260.

See Sona Johnston and Susan Boellendorf, *Faces of Impressionism: Portraits from American Collections,* exh. cat. (Baltimore: Baltimore Museum of Art, 1999), 96.

Van Gogh, *Adeline Ravoux*
See van Gogh, *The Letters of Vincent van Gogh* (London: Thames and Hudson, 1958), 3: 470, no. W22.

Van Gogh, *Large Plane Trees*
See van Gogh, *The Letters of Vincent van Gogh* (London: Thames and Hudson, 1958), 3: 239, no. 618.

Van Gogh, *Poplars at Saint-Rémy*
See van Gogh, *The Letters of Vincent van Gogh* (London: Thames and Hudson, 1958), 3: 220–21, no. 609.

Jongkind, *The Seine at Bas-Meudon*
See John Rewald, *The History of Impressionism* (New York: Museum of Modern Art, 1961), 70.

Léger, *Aviator*
See Edward B. Henning, "*The Aviator:* A Major Painting by Fernand Léger," *Bulletin of The Cleveland Museum of Art* 69 (1982): 88.

Magritte, *Secret Life*
See Isidore Lucien Ducasse (Comte de Lautréamont), *Les Chants de Maldoror* (1869).

Matisse, *Interior with an Etruscan Vase*
See Jack Flam, *Matisse. The Man and His Art 1869–1918* (Ithaca: Cornell University Press, 1986), 19.

Manet, *Berthe Morisot*
See Louise d'Argencourt and Roger Diederen, *European Paintings of the 19th Century* (Cleveland: Cleveland Museum of Art, 1999), 408.

Meunier, *Miners*
See *Rodin in His Time,* exh. cat. (Los Angeles: Los Angeles County Museum of Art, 1994), 163.

Modigliani, *Portrait of a Woman*
See Kenneth Wayne, *Modigliani and the Artists of Montparnasse,* exh. cat. (New York, Buffalo: Harry N Abrams, Albright-Knox Art Gallery, 2002), 36 (both quotes).

Mondrian, *Field with Young Trees*
See Mondrian, *The New Art—The New Life: The Collected Writings of Piet Mondrian,* ed. Harry Holzman and trans. Martin S. James (Boston: G. K. Hall, 1986), 14.

Monet, *Spring Flowers*
See Louise d'Argencourt and Roger Diederen, *European Paintings of the 19th Century* (Cleveland: Cleveland Museum of Art, 1999), 446.

Monet, *Wheat Field*
See Louise d'Argencourt and Roger Diederen, *European Paintings of the 19th Century* (Cleveland: Cleveland Museum of Art, 1999), 452.

Morisot, *Reading*
See Sona Johnston and Susan Boellendorf, *Faces of Impressionism: Portraits from American Collections,* exh. cat. (Baltimore: Baltimore Museum of Art, 1999), 128 (both quotes).

Pissarro, *Lock at Pointoise*
See "Jacob-Abraham-Camille Pissarro," in *Grove Art Online,* Oxford University Press, 21 December 2005, http://www.groveart.com.

Redon, *Vase of Flowers*
See *Odilon Redon, Gustave Moreau, Rodolphe Bresdin,* exh. cat. (New York, Chicago: Museum of Modern Art, Art Institute of Chicago, 1961), 36.

See Louise d'Argencourt and Roger Diederen, *European Paintings of the 19th Century* (Cleveland: Cleveland Museum of Art, 1999), 520.

Rodin, *Age of Bronze*
See Frederick Lawton, *The Life and Work of Auguste Rodin* (London: T. Fisher Unwin, 1906; New York: Charles Scribner's Sons, 1907), 45.

See John L. Tancock, *The Sculpture of Auguste Rodin: The Collection of the Rodin Museum, Philadelphia* (Boston, Philadelphia: David R. Godine, Philadelphia Museum of Art, 1976), 350 n. 9.

Rodin, *Balzac*
See Frederick Lawton, *Balzac,* chapter 17, 26 December 2005, http://etext.library.adelaide.edu.au/b/balzac/b19zl/chapter17.html.

Rodin, *Fallen Caryatid*
See John L. Tancock, *The Sculpture of Auguste Rodin: The Collection of the Rodin Museum, Philadelphia* (Boston, Philadelphia: David R. Godine, Philadelphia Museum of Art, 1976), 58 n. 69.

Rodin, *Pierre de Wiessant*
See John L. Tancock, *The Sculpture of Auguste Rodin: The Collection of the Rodin Museum, Philadelphia* (Boston, Philadelphia: David R. Godine, Philadelphia Museum of Art, 1976), 382.

Rouault, *End of Autumn*
See Soo Yun Kang, *Rouault in Perspective: Contextual and Theoretical Study of His Art* (Lanham, Maryland: International Scholars Publications, 2000).

Rouault, *Head of Christ*
See Ronald Goetz, "Finding the Face of Jesus," *Christian Century* 101 (1984): 299–302.

Segantini, *Pine Tree*
See Annie-Paule Quinsac, *Segantini* (Lecco: Oggiono, 1985), 720, no. 867.

Vuillard, *Café Wepler*
See Louise d'Argencourt and Roger Diederen, *European Paintings of the 19th Century* (Cleveland: Cleveland Museum of Art, 1999), 632.